THE PERFECT 100 DAY PROJECT

GIVE THE PERSON WHO
GOT YOU THIS BOOK A BEER.
OR A COFFEE. OR A BIG HUG.
OR A HIGH FIVE. EVEN IF
YOU GOT IT FOR YOURSELF.

The Perfect 100 Day Project
How to Choose, Make & Finish Your Creative Project
Rich Armstrong
www.taptapkaboom.com

Editor: Maggie Yates
Project manager: Lisa Brazieal
Layout design: Frances Baca
Cover design: Rich Armstrong
Proofreader: Stephanie Argy

ISBN: 978-1-68198-819-1
1st Edition (1st printing, March 2022)
© 2022 Rich Armstrong
All images © Rich Armstrong

Rocky Nook Inc.
1010 B Street, Suite 350
San Rafael, CA 94901
USA
www.rockynook.com

Distributed in the U.S. by Ingram Publisher Services
Distributed in the UK and Europe by Publishers Group UK

Library of Congress Control Number: 2021937327

Printed in Korea

THE PERFECT 100 DAY PROJECT

HOW TO CHOOSE, MAKE & FINISH YOUR CREATIVE PROJECT

RICH ARMSTRONG

rockynook

READ THIS FIRST

vi
HOW DOES THIS
BOOK WORK?

viii
WHO WROTE THIS BOOK?

ix
WHY DID YOU WRITE
THIS BOOK?

1
1. The What
and the Why

14
2. Common
Objections

GOOD CHAPTER IF YOU'RE UNSURE.

22
3. *The* 100 Day
Project

30
4. Designing
Your Project

READ THIS SECTION FOR SURE.

CON T

THESE ARE
PAGE NUMBERS

ALL THESE
ARE FOR YOU

74
5. Sharing

147
BLANK PAGES

92
6. Advice

165
INDEX

108
7. The Journey

126
8. Ending Your Project

142
9. The Last Few Questions

ALL THE
QUESTIONS

READ BEFORE
YOU END. OR
IF YOU WANT
TO STOP YOUR
PROJECT

ENTS

How does this book work?

This book is all about guiding *you* through designing, planning, and completing a successful 100 Day Project. It answers a ton of questions from all parts of the process—from discovering what a 100 Day Project is all the way to celebrating the end of your project and what to do next.

Each chapter is literally a question that I've written an answer to. You *may* have asked some of these questions in the past, or you *may* ask some of them in the future—most likely while reading through another chapter or when you're in the middle of designing, doing, distributing, or ditching your 100 Day Project.

SOMEHOW I MANAGED TO FIND WORDS THAT ALL BEGIN WITH 'D'

You don't *have to* read all the chapters—only the ones you want the answers to. Or the ones you're curious about. You also don't have to read the chapters in any particular order. You can jump around. You can flip to any page and read.

READ THOSE FIRST MAYBE?

Now, this book is not *me* giving *you* all the answers. In fact, you'll be co-writing this book. You'll be answering questions too. Questions that *only you* can answer. So, no, this is not a theoretical book. Nor is it a fiction or fantasy book. Or a steamy romance novel. It's an interactive, practical, personalizable, change-your-life book.

YOU CAN WRITE ONE OF THOSE IN 100 DAYS IF YOU WANT

Because of this you'll find tons of space to make this book your own. Feel free to write, draw, ~~cross out~~, underline, circle, highlight, and generally make the book a unique and priceless copy of *The Perfect 100 Day Project*. Because that's what a 100 Day Project is. A project for *you* right now. If at any point you run out of space, there's more space at the back of the book.

I hope this book helps you get closer to the person you want to become. And that you enjoy the process.

♥ *BIG LOVES*
RICH ARMSTRONG

I WROTE THIS BOOK. MORE ABOUT ME ON PAGE VIII

DOING SOMETHING CREATIVE FOR 100 DAYS WILL CHANGE YOUR LIFE.

Who wrote this book?

Hey! My name is Rich Armstrong. I'm a compulsive creator, a creativity geek, and a big dreamer. I've been making and creating things, mostly digital things, for a living since 2007. I studied Brand Communication, and then Graphic Design. I taught myself how to code. I've been a freelance Graphic Designer, worked as an Interactive Designer at a Digital Agency, been Employee Number One at a startup, and when we moved from South Africa to Amsterdam in 2016, my wife and I started our own Product Design studio.

When someone used to ask me what I did, I couldn't give them a good answer. Design. Illustration. Animation. Coding. UX. UI. Apps. Websites. I create stuff alright!? But I answer this question differently now.

Because in 2015 I began creating online classes. I began teaching stuff in ways I wish I'd been taught (and some stuff in ways I was taught). On a growing range of topics. And over time, creating these classes, responding to student's questions, and giving feedback on projects took up more and more time. And now this is what I do with most of my time. With my wife. It's called TapTapKaboom. And because of this I get to see people change, grow, learn, and succeed. Seeing people take action, create intentionally, play, experiment, find what makes them come alive, and realize they can do it—this is what gets me up in the morning. I love helping people do all that. And the more I learn the more I teach and try to help.

You can find more of what I do at **www.taptapkaboom.com**

ALSO, I CAN TOUCH MY NOSE WITH MY TONGUE!

Why did you write this book? *LIKE, HVVVVGE!*

In short, I wrote this book because I'm a *massive* 100 Day Project fan.

When you find something awesome *and* readily available to all, you'd share it too, right?! You'd tell people about it, rave about it, blog about it, post on social media about it, make a video about it. Or if you're a journalist, you'd write an article about it. Or if you make online classes, you'd make an online class *all* about it. Which is what I did in 2019. I made an online class about 100 Day Projects and how to do one. And thousands of people have taken it.

MAYBE YOU'D EVEN WRITE A BOOK ABOUT IT!

How did this all start? In 2015, as a UI/UX designer working for a startup, my creativity was shriveling up. So I decided to do something about it: doodle every day. And for 100 days I drew one of several random words. I didn't know who Elle Luna or Michael Beirut were in 2015. I didn't know 100 Day Projects were a thing. I just wanted to do something about my shriveling-up creativity. And it changed everything. *SERIOUSLY. EVERYTHING.*

Taking responsibility for my creativity, and doing something about it, led from one thing to another. Creating online classes. *Attempting* to write books. Month-long vacations. Uprooting our lives to another country. Starting my own business. Learning a foreign language. Doing business with international clients. Traveling 10–12 weeks a year. *Writing* a book. It's been an epic journey. And I put it down, in some small way at least, to doing that first 100 Day Project.

Since then I've done a few more 100 Day Projects. Some have been failures. Others have been successes. And every time I do another 100 Day Project I'm amazed by how it prompts change, growth, and self-discovery. And how it helps me start *and* finish things. I've also seen tons of students' 100 Day Projects and heard stories of how 100 Day Projects have changed people's lives.

THIS HAS BEEN AMAZING TO SEE!

I've learned a ton. And I want to share that ton with you in this book. I want to empower *you* to change *your* life through the structure and flexibility that a 100 Day Project offers. I want to break your assumptions. I want to answer your questions. I want you to learn new things. To get things done. To grow. To discover who you are. And most importantly, to succeed. I want you to get closer to the person you want to become. And I believe a 100 Day Project will help you do that.

FUN FACT: I DID NOT WRITE THIS BOOK IN 100 DAYS

THE WHAT
AND THE
WHY.

ḦAT

THIS CHAPTER IS A MVST READ!

2
What is a 100 Day Project?

4
Why are 100 Day Projects so popular?

5
Is a 100 Day Project difficult to do?

7
Why should I do a 100 Day Project?

13
Why shouldn't I do a 100 Day Project?

YEAH, SOMETIMES IT'S NOT A GOOD IDEA

What is a 100 Day Project?

A 100 Day Project is a project where you choose something to do every day for 100 days.

The thing that makes a 100 Day Project powerful isn't starting one day and finishing 100 days later. No. It's doing something *every day* for *100 days*.

A lot of people tell the world they're doing a 100 Day Project before they begin. And share their process on a daily basis—these two things happen most frequently on Instagram. But sharing *is not* a requirement, and neither is sharing on Instagram.

That's it. That's all a 100 Day Project needs to be. But that doesn't get to what a 100 Day Project *really* is. Or what it *could* be.

I believe a 100 Day Project is a personal project where you do something *creative* every day for 100 days. You choose what to work on. How to work on it. When to work on it. And why to work on it. You make the rules.

The project originates from a graphic design background. So, many of the projects you'll see are "creative" projects. I put quotes around "creative" to connotate typical "creative" activities like drawing, painting, crafting, writing, designing—that kind of stuff. But I believe the word *creative* is far more universal and broadly applicable.

How you define *creative* will change how you see a 100 Day Project. People have overcome fears every day for 100 days. Others have worked out, run, meditated or done yoga for 100 days. Others have baked, learned new cooking skills, or eaten vegan. And still others have sent messages to friends each day. These are all *creative* projects.

"Creative" projects can be *creative* projects.

But not all *creative* projects are "creative" projects.

Being *creative* is being deliberate. It's choosing. It's being intentional.

When you're intentional, you create the life you want to live and the world you want to live in.

THIS IS SUPER IMPORTANT

If you're not creating, life happens *to* you. You operate on auto-pilot. Autopilot life, especially when it's comfortable, may look nice. But living intentionally is far better.

What a 100 Day Project provides is a structured framework to *create* within: intentionally doing something every day for 100 days. Beyond the framework, it's an incredibly loose and flexible format. You can do *whatever you want* for 100 days. However you like. Wherever you like.

You can add something to your life. Or remove something from your life. You can play. You can experiment. You can indulge a curiosity. You can learn something. You can practice something. You can achieve something. You can work toward something. You can do less. You can sit in silence for 5 minutes every day. There are so many possibilities. *SOOOO MANY!*

Over the course of 100 days you have an opportunity to pursue more of what you want in your life, or become more of the person you want to be. Without anyone telling you what to do. No clients, no boss, no customers. This is where it gets scary and interesting and weird. Because most of us aren't used to pursuing what *we* want. Most of us don't even *know* what we want. Most of us aren't used to *creating* our own lives.

That's what this book is for—to help you figure out what you want, and to help you take action on it.

Instead of going with the flow. Instead of reacting. Instead of saying yes only because there's a bigger paycheck. Instead of complaining. Or resigning yourself to what happens. Or waiting for something better to turn up. Or waiting for someone to pick you.

It's time to *create.*

It *could* be drawing every day. It *could* be learning how to play the guitar for 100 days. It *could* be writing letters to your child as they grow in your womb. It *could* be being kind and generous for 100 days. It could be *anything.*

What you do for your 100 Day Project is your decision. This book will help you choose a project. It will help you adapt it. And it will help you learn and grow as much as possible.

I AM BEYOND EXCITED FOR YOU!

THEY'RE AMAZING. AND EPIC.
AND AWESOME. AND FREE!

Why are 100 Day Projects so popular?

Firstly, the name has a nice ring to it. A 63 day project, 87 day, or even a 30 day project, doesn't sound nearly as good, does it? A 100 Day Project sounds like a *thing*. Official. Big. Round. Oddly specific. Easy to comprehend. Simple to explain.

And 100 days is challenging—even if you've done one before. But it's especially challenging for first-timers. It may even feel like a rite of passage. I often hear whispers, "Have *you* done a 100 Day Project?" "What did you do yours on?" But doing something for 100 days is attainable—thousands of people have *done* it.

But what makes 100 Day Projects truly shine is their versatility and community. At any given time there are thousands of people *doing* a 100 Day Project. While someone's tying 100 different knots, someone else is trying 100 different sex positions. While someone's drawing 100 faces, someone else is illegally spray painting 100 walls. There are all kinds of people from all kinds of places intentionally doing all kinds of self-directed projects. It's a project where everyone is doing something different for different reasons, and calling it the same thing: a 100 Day Project. It creates an epic and super interesting community.

Then, when you get to the end of those 100 days, you're a changed person. It's like something clicks inside of you—a very slow click, over the course of 100 days—but still, a click. And because of this change, people rave about it, share it, and swear by it.

CLLLIIIIICK

Is a 100 Day Project difficult to do?

The 100 Day Project was originally described as a *Creativity Challenge*.

A challenge.

It's meant to be hard. It's meant to push you out of your comfort zone. It's meant to be intimidating. It's not just 1 day, or even 10 days. It's not a sprint or an easily checked-off item on a task list. It's just over 3 months long!

It's hard to *choose* something to do for 100 days.

It's hard to *do* something for 100 days.

But this is the point.

It's where you challenge yourself.

To create.

To grow.

To learn.

To commit.

To be disciplined.

To act.

To try.

To change.

To better your life.

For 100 days.

It's a long time.

But 100 days is not unfathomably long. It's not *forever*.

It's worth the effort and time and energy and discipline.

IF YOU ARE
NOT IN THE
PROCESS OF
BECOMING THE
PERSON YOU WANT
TO BE, YOU ARE
AUTOMATICALLY
ENGAGED IN
BECOMING THE
PERSON YOU DON'T
WANT TO BE

—DALE CARNEGIE

Why should I do a 100 Day Project?

Before I answer this question, let's get something straight: *should* is a sucky word. Don't do a 100 Day Project just because you feel like you *should* do one. That's like saying you're doing it because you *have to.* Do it because you want to. Or because you're curious to see what happens.

What follows in this chapter are a bunch of possible reasons why you may want to do a 100 Day Project. It's possible that you may not care for all the reasons. And it's highly likely that not all the things listed will happen to you. It's also likely that you'll experience things that aren't listed here. → *TELL ME WHAT YOU EXPERIENCE!*

It crystallizes what you want. I bet you have a bunch of dreams and goals floating around in your mind. You want your life to be different. You want the world to be different. *You* want to be different. But you probably don't know what the next step looks like. When you *have to* do something every day for 100 days you visualize what your dreams and goals *could* look like. And then you do them. Rather than staying inside your head where dreams and goals circle in a hazy mist. When you take steps toward something you want, you discover whether that something *is* or *isn't* actually what you want. If it is, awesome—now you know for sure! And if not, then you know! You can then adapt and change your journey's course. Both these findings bring clarity to what you want.

It makes what you want achievable. Maybe the things you want *are* crystal clear. But they're huuuuuge. And you're overwhelmed by how to get closer to achieving them. Within the structure of a 100 Day Project you can break down the big things you want into manageable steps to take on a daily basis. Whether that's becoming super fit, becoming an Adobe Certified Professional, building a money-making product, or getting your yacht-skipper's license, or anything else, you get to intentionally and incrementally and consistently work toward something you want. And in a way that doesn't stress you out. A 100 Day Project isn't a quit-your-job kind of project. It's about working within the constraints and rhythms of *your* life. What you learn will show that you don't "have to have it" in order to do something—it will show you that you can learn as you go. That you can work at something and get better at it and build up to it.

It prompts you to take action. With a 100 Day Project, the point is to create every day. Which means you need to take action. Every. Single. Day. You need to make today's creation happen *today.* And no matter what, tomorrow is about tomorrow's creation. It can be tough and challenging. But because there's an end in sight, it's doable and it motivates you to do the work.

It weeds out perfectionism. When you create every day, you'll produce some not-so-hot stuff. But you will produce. This quantity-over-quality attitude prompts you to create without worrying about creating perfect things, or fitting in, or doing the right thing. But quantity *does* lead to quality. So, by creating every day, no matter what, you'll create the good stuff eventually—even if you have to produce a bunch of meh stuff to get there. *MEH STUFF CONTAINS SPECKS OF GOLD.*

It helps you become efficient and productive. Because you'll be doing something every day you'll begin to spot things that hamper your productivity. Things that slow you down. Things that distract you. Things you procrastinate with. So you'll smooth off rough edges. You'll learn from your mistakes. You'll ditch the distractions. You'll organize your time better.

It teaches you that you are not what you create. Because you're creating every day, you'll soon realize that sometimes you create epic stuff, or perform really well. And yet on other days you create terrible stuff, or perform badly. The penny often drops when you see what you do side by side in such a short period of time: you are not what you create or how you perform.

It prompts you to choose. If you can't even consider working on something for 100 days, then is it worth considering at all? Perhaps it's better to scratch it off your to-do list forever. A 100 Day Project is an amazing way to filter out what's not important and valuable to you. It prompts you to pick just one thing to focus your attention on. One thing to prioritize. You may be someone who struggles to say YES to anything, or someone who struggles *with* saying YES to everything. Doing a 100 Day Project means saying YES to *something,* and NO-FOR-100-DAYS to the other things you want to do or try or not miss out on. This may mean saying NO to learning 3D because you're saying YES to learning to code. Or NO to meditating daily while you say YES to gardening. And for many of us this looks like saying NO to series, social media, and mobile gaming. While we say YES to something that truly matters to us.

It teaches you discipline and the value of consistency. With the right 100 Day Project, you'll find yourself showing up day after day. Excited. Curious. Eager. You'll learn how to do something slowly. Deliberately. Patiently. You'll learn how to pace yourself and do things in a sustainable manner. And each day will reinforce that you can be disciplined. And after a few days, or weeks, you'll learn how valuable and underrated consistency is—especially when compared to intensity and trying to do everything right now. A 100 Day Project is not a sprint. It's more like a marathon you can only do at tortoise speed. → *THE TORTOISE BEATS THE HARE.*

It helps you grow and discover yourself. A 100 Day Project is hard. And long. It stretches *you*. You develop. You progress. You grow. You learn a ton about yourself. What makes you tick. What frustrates you. What works for you. What doesn't. What you like and dislike. What bores you. What makes you feel glum. What motivates you. What you're good and gifted at. What distracts and derails you. What you're capable of. You'll learn what your rhythms and routines and processes are like.

All this becomes apparent and sticks out far more during a 100 Day Project— like a sore thumb would if you kept on bumping it every single day. Because *I LOVE THIS LINE* condensed repetition reveals patterns and beliefs and thoughts and feelings that you wouldn't normally see. It's like self-development on steroids. No matter who you are and what you choose to do for 100 days, a 100 Day Project is a self-discovery project. Even if the project you choose sucks monumentally, or if you quit after 6 days, you'll learn something about yourself.

You'll discover all kinds of opportunities. When you're on this 100-day journey, you'll find all kinds of new paths and options and opportunities. There will be plenty of forks in the road—that you would never have got to, never have found, if you weren't on the journey.

It shows you how to make changes in your life. A 100 Day Project shows you the principles of tackling something big, and making an intentional change to your life. These principles can be replicated and adopted for all kinds of things, especially the big things—moving countries, career changes, year-long projects. It makes future changes in your life far more attainable. You'll learn that if something isn't right, you often have all it takes to change it.

CHECK OUT MALCOM GLADWELL FOR MORE ON THIS TOPIC

It allows you to up-skill yourself. When you work on something every single day you get better at it. And quicker. And depending on what you do, you'll master a combination of new and existing skills. You'll inch closer to the 10,000 hours of mastery in various fields. Seriously, the quality and speed of what you do by the end of your project will surpass what you did in the beginning. Because a 100 Day Project gives you a daily opportunity to learn, recall, and practice what you know and what you've recently learned. And it won't be theoretical learning. It will be compoundable practical learning you rack up. Because you'll be creating from where you left off of the day before. Not just researching. Not just reading.

POWERFUL STUFF

It gives you confidence and builds momentum. Because you're doing something every day for 100 days, you can see your progress and gauge the difference it makes. The difference becomes visible and measurable. There's proof that you're better, quicker, smarter, more skilled, more creative. Whatever the skill or feeling is, you feel more confident in it. This then bleeds into the rest of your life. And you begin believing you can do a lot more than you when you started— maybe even tackling those projects that used to overwhelm and scare you.

It helps you be autonomous. Many of us are doing what we're told—and *only* what we're told. We're not being autonomous. We're not making our own decisions. We're not working on the things we want to. We're saying yes to everyone and everything else. Except our intuition. Except our ideas. Except our dreams and goals. Except ourselves.

A 100 Day Project breaks that norm and gives you an opportunity for autonomy: a chance for you to take charge over a small project that is your own. One that you don't have to fit into budget, where you don't have to do it for money, where you don't have to get it done in 2 days. This is where you get to decide what to work on, how long to work on it, and why to work on it. A 100 Day Project will give you a little more autonomy, control, and responsibility. And warm you up for more—if that's what you want.

It gives you a chance to try a life on. If you've always wondered, "What if…" What if I moved to Italy and made ceramics? What if I became a musician? What if I started my own business? What if I were to backpack the world? What if I was *that* someone, or doing *that* something? Well, with a 100 Day Project you can try *that* thing on for 100 days. See if the real thing is anything like what you've imagined it to be. Before you spend the money. Before you burn the bridge. Before you take a leap into the deep end, without knowing if you like swimming—or if you can swim at all. And if *that thing* fits, you can keep it. If it doesn't you can return it and try something else on. *A GENEROUS RETURN POLICY*

It prompts you to create more than you consume. By being required to create every day, you'll see the time you used to spend consuming content be eaten into by being *creative*. The more you create the more your brain will crave it. Your imagination will catch on fire. And this will make you feel alive. A 100 Day Project makes doing this easier. Because you have a goal, a structure, a deadline, a commitment—and people rooting for you!

It helps you realize what's possible. When you complete your 100 Day Project you feel amazing. It's an *epic* achievement. Because, before that, you didn't realize what was possible. You didn't realize that *you* were possible. Things are different from that moment on. You believe you *can* do things. Big things. Hard things. Challenging things. Things that add value to your life. Things that other people find difficult to do. A new website to attract clients. A personal branding overhaul. Learning new skills. Self-care. Prioritizing mental health. Almost anything will seem possible when you've completed a 100 Day Project.

Even if you end up gritting your teeth and hating every day of your 100 Day Project (maybe you work on something necessary rather than something you enjoy doing) you'll learn a lot about getting stuff done. About showing up. About being professional. About doing stuff for future you. 100 days is a good teacher.

It will surprise you. Until you've gone through your 100 Day Project, you won't know what's going to happen. You won't know what you'll learn. Or how you'll change. Or how life will change. Some things will only become apparent on day 89. Other things will surprise you on day 24. Or even on day 2. There is no way of knowing. This is a project where you invest time and see how it plays out. Much like watering a seed, and waiting to see what kind of flower it is. It's an invitation to spend time on something and see it flourish.

So, what appeals to you about a 100 Day Project?

If you're not sure about a 100 Day Project, begin one. Create something for 5 minutes a day. Give it a chance. See what happens. But don't feel like you *should* do one. There's no pressure. Don't rush. Come back to it when you're ready.

Do you want to do a 100 Day Project?

CIRCLE AN OPTION LIKE CRAZY

HECK YES! OR NO WAY!

Why shouldn't I do a 100 Day Project?

Most of the time I'm all about anyone doing a 100 Day Project. Even if you're unsure or super busy. But there are times when it's not the best idea.

→ THIS IS NOT A TYPO

Don't do it if you *really really* don't want to do a 100 Day Project. Doing something when you don't want to, for whatever reason, will normally lead to mediocre results—at best. You won't put in the effort. You won't try as hard. You won't even try to have fun. You'll get over it quickly. You'll probably even sabotage your own project. Rather, come back when you *want* to do one.

Don't do it if the only reason you're doing it is because everyone else is doing it. Don't give into that pressure. It's a good place to get you curious about a 100 Day Project. But then spend some time figuring out *why* YOU *want* to do it. This may delay you a few days, but that wait will be worth it.

Don't do it to compete with others. The only person you're competing with is yourself. You can only improve *your* life. And you can only control what is in *your* ability to control. If you compete with others you'll begin the comparison game. Which will either make you feel like you're not good enough, or you'll puff yourself up with pride. And it's highly likely that you'll ping-pong between the two: self-loathing one day, super-proud and boastful the next. You could work on this attitude before you start, or you could design your 100 Day Project around addressing competition and comparison. It may mean that you don't share your 100 Day Project. Or that you avoid social media for 100 days.

Don't do it to get rich, famous, or popular. Or anything else outside of your control. You may not get famous or rich, and you may not attract the audience you want. Only do it if you're 100% okay with not gaining any outcome-based result because of your 100 Day Project. *DO IT FOR AN INTRINSIC REWARD*

Don't do it if you've got a huuuge work load. Consider delaying the start of your 100 Day Project until you've completed some other projects you're working on—especially if they're also daily projects. Adding another spinning plate to your life may cause you to drop a few others. Some people thrive when doing more. Most people fare much better when doing less.

2

COMMON OBJEC

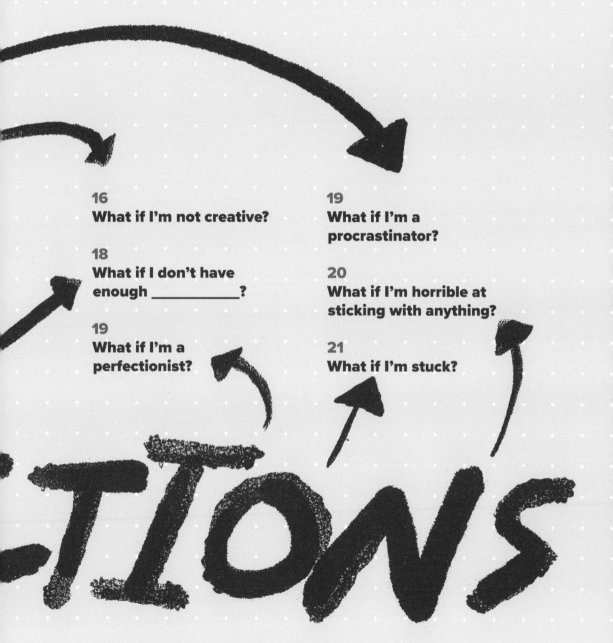

16
What if I'm not creative?

18
What if I don't have
enough _____?

19
What if I'm a
perfectionist?

19
What if I'm a
procrastinator?

20
What if I'm horrible at
sticking with anything?

21
What if I'm stuck?

:TIONS

What if I'm not creative?

You're screwed. I'd check if you're actually human.

Okay, that was harsh.

What I mean by that is that you are creative.

No matter how uncreative you *think* you are.

Because you're human.

You don't need to be in a "creative" career or be artistic to think of yourself as *creative*. Every decision you make is a creative act that shapes your life in some way or another.

And you get better at creating the more intentional you are about what you're creating and why.

So, you don't have to be an artist or an aspiring artist to do a 100 Day Project.

You just need to be you.

You are a *creative* being.

And even if you *still* think you're not *creative,* you can still do a 100 Day Project.

AS A LAST RESORT

YOUR LIFE IS YOUR GREATEST CREATIVE PROJECT

What if I don't have enough _____?

Don't have enough time, money, or equipment? Make your project fit your constraints. Do a *version* of your project. If you'd love to travel the world for 100 days but can't, maybe visiting a new café each day is an option.

THIS IS POSSIBLE

If time is a big issue for you, start making time. Ditch Netflix. Ditch social media. Ditch gaming. Don't hit snooze. Get up when your first alarm clock goes off. Have a shake instead of that English breakfast. Then do your project with the time you just carved out of your day. If you still don't have time, choose a project that fits your schedule and routine. If you travel, make your project mobile. If you only have time at night, make it quick and quiet.

Perhaps you want to cook for 4 hours every day for 100 days. But if, in reality, all you can do is make a new smoothie every morning, do that. Maybe on the weekends spend more time cooking. And if the only free time you have is when you commute, listen to cooking podcasts, or watch cooking shows.

BUT NEVER STEAL

If equipment or money is an issue, beg and borrow. Explain what you're using it for and why it's important to you. Offer some of your time in exchange for what they're lending or giving you. If you borrow a camera to make stop-motion animations, you can take photos of the person you borrowed it from. If your parents helped you out with money for an iPad to illustrate sea creatures, make them ocean-themed birthday cards and illustrated prints. And if no one is able or willing to lend or give you anything, <u>make it work with what you've got</u>. Draw in the sand. Sing out loud. Use your phone.

Be resourceful.

Be humble.

Be hungry.

Don't wait for the stars to align.

<u>Something is better than nothing</u>.

What if I'm a perfectionist?

Well, then, a 100 Day Project is perfect for you. Set yourself parameters that make it *impossible* to create anything that's remotely near perfect. And lean into it. Practicing imperfection makes it easier to accept imperfect work. So, aim to create imperfect work.

What if I'm a procrastinator?

Do 100 days of procrastination as your project. Perhaps you procrastinate by doodling, or watching Marvel movies, or by making little movies. Why not design your project around those things? *THAT COULD BE FUN...*

Or make your project *very* easy to get started. Or maybe don't eat or don't drink coffee until you've done your project each day. A 100 Day Project is a great way to unlearn the habit of procrastination, or to lean *into* the things you procrastinate with—the things you *want* to spend your time on.

A 100 Day Project will also give you the structure to break big tasks down into small daily tasks—ones that may take even less time than what you're procrastinating with.

What if I'm horrible at sticking with anything?

A lot of people tell me they're *too creative* to do a 100 Day Project. They can't handle the structure. They're not disciplined. They can't be consistent, focused, or build a routine. I believe these same people know that these abilities lead to greatness, and that by ignoring them they're sabotaging what they want to achieve. Is this you? Do you know that if you could just stick to something you'd achieve your wildest dreams? If you could just continue showing up you'd be forking amazing?

LEARN DISCIPLINE THE EASY WAY.

Discipline is not a fixed trait. It's learned. And a 100 Day Project is one of the best places to learn it. Why? Because you can work on *anything* you want. You can make it as small as you want. As weird as you want. As fun as you want. You get better at sticking to things by making it easy to stick to things. Choose a project that doesn't feel like a project—one that's fun, challenging and rewarding. You could doodle for one minute every day. You could dance every day. You could message someone new every day. You could even do #100NewThings. What could possibly make you do it for 100 days? Think of *that* project.

If the mere idea of doing something for 100 days freaks you out, do seven days, or even just one day. And then another. And then another. Each day you show up to do your project you'll reinforce that you can be disciplined. That you can stick to things. That you can be consistent.

And when you have an idea for a new project, or another thing, write it down. Set a reminder to do it later—after you've completed your 100 Day Project.

THERE'S LOTS OF SPACE AT THE END OF THE BOOK

What if I'm stuck?

Being stuck, whether you've consciously acknowledged it or not, is the very reason a 100 Day Project exists. You can be stuck in all kinds of areas in your life. Career. Creativity. Relationships. Health. Fitness. Money. And whatever else. It's often more than one. And one is often the cause of another.

I know what it's like to be stuck. It doesn't feel good. But a 100 Day Project welcomes you wherever you're at, and helps you get unstuck. You don't have to be perfect to begin changing your life—that would just be weird.

If all you can manage is something simple and basic, do that. Show up. And you'll see how doing this day after day will unblock those pipes. What comes out will most likely not be good or fun or life changing, but these are often the things clogging you up. It's best to get it out. And during the process you'll see change. You'll learn. You'll discover. You'll begin to feel alive again.

THIS OFTEN MAKES US STOP — BECAUSE IT'S NOT AS GOOD AS WE WANT IT TO BE... BUT PUSH THROUGH — YOU'LL EVENTUALLY GET TO THE MAGIC.

THE 100 DAY PROJECT

ITALICIZED
BECAUSE IT'S
DIFFERENT TO
A 100 DAY PROJEC

THERE IS AN
IMPORTANT
DIFFERENCE!

24
**What's the difference
between a 100 Day Project
and *The* 100 Day Project?**

29
**What are the dates
of *The* 100 Day Project?**

27
**What's the history
of *The* 100 Day Project?**

29
**Do I have to start and
end *The* 100 Day Project
with everyone else?**

THIS IS WHERE
IT ALL BEGAN

ALSO, YOU CAN
JUDGE MY DRAWING
SKILLS IN THIS
CHAPTER

What's the difference between a 100 Day Project and *The* 100 Day Project?

The short answer: *The* 100 Day Project is an annual version of *a* 100 Day Project that's run by someone at a specific time in the year. There's community. There's vibe. Tons of people get involved each year. And a lot of them are 100 Day Project repeaters.

Read on for a longer answer.

The difference is comparable to the difference between doing a marathon by yourself and running an organized marathon. You *can* run one by yourself. And it would be an epic achievement. I'm pretty sure it would be harder. There would be more traffic for sure. Maybe it would be fun (if you're in to long-distance running). You could listen to podcasts and music and run without the hype and stress of all the other people. You could also run it with a friend—great bonding time. Or you could run an official marathon with tons of other people (maybe with a friend still). The roads would be closed. There would be a starting gun. A finish line. You'd get free bananas and water along the way. Crowds of people would be cheering you on (and everyone else). You get the point.

DON'T WORRY! IT'S NOT A CULT!

The 100 Day Project is an annual thing. It happens once a year, and only once a year. It has a start date and an end date that's decided by *the facilitator*. So yes, you're slightly at their mercy but the rhythm of doing it once a year makes up for it. *The* 100 Day Project is part of the creative calendar. It's like the creative equivalent of the Boston Marathon. Or New York Marathon. Or Comrades Marathon. Or London Marathon. Hopefully one of those marathons seems hella-big to you. *The* 100 Day Project is a big thing. And tons of people do it. Everyone's doing their self-directed 100 Day Projects together—for 100 days. There are official graphics, official newsletters, official groups, official Q&As, live sessions, and a bunch of other official stuff that accompany *The* 100 Day Project. If you're familiar with NaNoWriMo, Inktober, or 36 Days of Type, then it's something like that. There's community. There's accountability. There's hype. There's curiosity about what other people are doing that year.

I'M NOT A MARATHON RUNNER BUT I'M IN AWE OF PEOPLE WHO ARE. CAN YOU TELL?

But sometimes all that is *not* what you want. Maybe it's never been what you want. Maybe you don't like the disheartening idea of being just another fish swimming upstream. Or of comparing your work to so many people doing the project at the same time. Then you'd be pleased to know that you can do *a* 100 Day Project anytime you like. *A* 100 Day Project is completely self-directed, self-planned, self-motivated, self-everything-ed. You can start now, and not have to wait 257 days before *The* 100 Day Project kicks off again. You can consider and plan your project before rushing to set off. You can run alone, without all the hype and noise, and just do *your* thing.

What appeals to you about *The* 100 Day Project?

What appeals to you about *A* 100 Day Project?

Which one are you leaning toward?

DRAW YOUR FACE ON ONE

THE — OR — A

There are pros and cons to both approaches. And the experience, the results, the learnings—all of it—could be different if you go one way or the other. But you can also remove and change and borrow from both approaches. You can customize whichever approach however you want. If you want to shoot a starting gun on day one, go for it. If you want to want to blog or vlog or write publicly about it, do it. If you want to give yourself a medal at the end, heck-yes! do it!

If you don't know whether to go solo or join *The* 100 Day Project procession, think of starting your project within the next 30 days. If it's close to the start of *The* 100 Day Project, do *The* 100 Day Project. If it isn't close to the start, do your own thing. Whatever you decide, know that this project is in your hands. It's yours.

PLEASE BE SENSIBLE
ABOUT WHERE YOU
DO THIS, IF YOU DO.

What's the history of *The* 100 Day Project?

Way back in 2007 this super famous graphic designer named Michael Beirut began teaching a workshop called *The 100 Day Project* for graduate graphic design students at Yale School of Art. Yes—fancy! He birthed this workshop because he'd been doing year-long daily projects and wanted to bring this same style of project to students. He designed the project to be done as a warm-up. Like doing scales, or stretching. Light. Fun. Something you do before you jump into more intense work. But he knew it would also teach students habit-formation and discipline. Which was something quite different to the design projects students were used to.

YES. THAT'S 365 DAYS EACH YEAR !

And so the workshop was born. But it needed a name. And thank God there were 100 days between the start and end date of the class. Because The 102 Day Project just doesn't sound as good. So, The 100 Day Project. Capitalized. That was what Michael brought to the table. He gave creating for long periods of time a name and a long-but-not-too-long duration. It made it big and challenging and cool. And it became something students looked forward to. Because the projects were cool. And fun. And creative. And surprising. Some students even became famous because of their 100 Day Projects they did at Yale.

So now it was a *thing*. Then Elle Luna, this awesome designer writer artist author lady, made it an even bigger thing in 2014. She brought it to the Internet. Without the permission or blessing of Michael Beirut. But he didn't mind, which was rad. What this act decreed was that *The* 100 Day Project wasn't limited to Yale's graphic design department. It made *The* 100 Day Project available to anyone and everyone. For free. You didn't have to be a *someone* to do the project. And it showed you didn't have to play by the rules, nor ask permission to do your own 100 Day Project. Next, Elle added *official* dates and encouraged people to tag their daily 100 Day Project posts with #The100DayProject on Instagram. It exploded the first year it went public, and has grown in popularity ever since. And this is *The* 100 Day Project that most of us know today.

Elle then handed the baton on to Lindsay Jean Thomson in 2019, who had helped facilitate things for a few years before that. Lindsay's a writer and heroic community builder. She runs a tight ship facilitating *The* 100 Day Project each year.

Because of the work and generosity and creativity of these legends (and most likely tons more unseen and unwritten of) we have *The* 100 Day Project. This annual thing with a rad name. This movement. This community. This way to spend time intentionally creating.

Thank you Michael.

Thank you Elle.

Thank you Lindsay.

And thank you to all the other people who've had a hand in making 100 Day Projects what they are today. You're all legends.

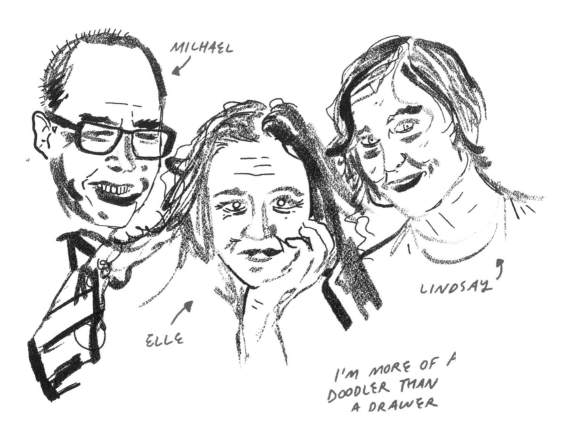

MICHAEL

ELLE

LINDSAY

I'M MORE OF A DOODLER THAN A DRAWER

What are the dates of *The* 100 Day Project?

The 100 Day Project normally kicks off on the first Tuesday in April.

In 2021, surprise! It kicked off on January 31. Because of COVID. Pandemic. Lockdown. People needed something. And *The* 100 Day Project gave them that something. It got people into action. It was a good move.

So, to find out when the next one is visit *The* 100 Day Project website at **www.the100dayproject.org**

Do I have to start and end *The* 100 Day Project with everyone else?

Nope. You don't have to start *The* 100 Day Project with everyone else. So, if you don't have to start on the same date, you certainly don't have to finish on the same date. Even missing one day and adding it onto the end would mean you don't finish with everyone else. I guess you could say you're doing *The* 100 Day Project if you started at some point between the official start and end date.

But, no one is checking. You're not registering. You're not paying. And you're not getting a medal or a certificate at the end. *WELL, UNLESS YOU'RE GIVING YOURSELF ONE, WHICH WOULD SUPER COOL*

DESIGNING YOUR PROJECT

READ THIS CHAPTER!

32
How do I choose my
100 Day Project?

60
Do I need to do a
"creative" project?

60
Can I merge what I'm
currently working on into
a 100 Day Project?

61
What types of projects
are there?

62
What makes a good
project?

63
What if I'm struggling to
choose my project?

65
What if my last project
was a huge success?

67
How do I choose my
subject matter each day?

68
Can I pick an outcome-
based goal to achieve for
my 100 Day Project?

70
What if someone has
already done my project?

72
How much time should I
spend on my project?

73
What if I'm traveling
during my 100 Day Project?

73
Can I do more than one
project at a time?

How do I choose my 100 Day Project?

After "What is a 100 Day Project?" this is by far the most asked question when it comes to 100 Day Projects. This is the chapter where you design a 100 Day Project for yourself. One that addresses your needs and desires. And one that fits into your life. It's a big chunk of this book. Because it's important. It's also highly practical. So go grab a pen or pencil.

First of all, do you have an idea of what you're doing for your 100 Day Project?

Maybe...

IT'S A GOOD SIGN

What you're doing for your 100 Day Project is hella-clear. It may be calling to you. Shouting at you. Badgering you. You may feel you're destined to do this thing. Heart pumping. Bones jingling. Eyes wide with excitement. Sometimes you just *know* what your 100 Day Project is going to be.

You're not thinking too much about it and just kinda winging it. There's a feeling there. You've got a gut instinct. You just want to see what happens.

What you want to do is there, but it's vague. You have an idea, but you can't put your finger on it. Lots of head and chin scratching. Hmmmm.

You have a butt-ton of options you're contemplating. And they're all super-duper-exciting. But you have no idea how to make the choice.

KID FRIENDLY BOOK

You have no clue what your 100 Day Project is going to be. But a 100 Day Project still sounds forking appealing.

You have tons of voices telling you what you *should* do. But you're not sure if they're what *you* actually want or need.

Some people say don't overthink what you do for 100 days. Overthinking isn't good, but thinking *is*. Being intentional and purposeful is. Being strategic is. And no matter where you stand on choosing what to do for 100 days, the exercises in this chapter will help you figure it out, clarify it, and make it awesome-er.

During this process, I want you to generate a ton of project options to choose from. Some will be clear no-nos. Some will be oh-my-goodness-yeses. And the rest will be somewhere in-between. There is no universal "right" kind of project. And no project is *always* going to be better than another. Your final choice of project depends on all kinds of things, and those things may change over time. You may have no job and tons of time now. This means you can spend 5 hours a day learning how to code. Some projects make more sense if you're single. Some make more sense if you have kids. Some if you're overstressed and tired. Some ideas you pen down may be more suitable for another time. And a few will be exactly what you want and need right now. Some options could be starting points for future 100 Day Projects. Others could be things you outsource, things you do in shorter timespans, or things you slowly implement into your life.

The following five exercises are not entirely linear. Some questions may even prompt you to go back a few steps. Which will change things going forward again. And this is the point. Let the exercises help you figure out what you want, what's important to you, and how to fit them into a 100 Day Project.

1. **Brainstorm Project Ideas.** Page 34
2. **Discover the Reasons.** Page 48
3. **Acknowledge Your Constraints.** Page 53
4. **Define Your Parameters.** Page 56
5. **Choose Your Project.** Page 59

EXERCISE 1

Brainstorm Project Ideas

In this first exercise you'll be brainstorming project ideas by listing project ingredients and then combining them into "What if I _____ for 100 days?" questions.

Write down as much as you can in the following 10 sections while you read. And then add to it over the next few days as thoughts and ideas pop into your mind—especially while going through the other exercises in this chapter. Don't worry, you're not going to add all these things into your 100 Day Project. They're ingredients for possible projects.

If you get stuck on one section, jump to another.

If you already have an idea for your 100 Day Project, do this exercise anyway! It will help you refine your idea, and possibly make it even more awesome.

You'll be listing project ingredients around these questions:

1. **What are you currently doing?**
2. **What do you want to get done?**
3. **What do you want more of in your life?**
4. **What are you good at?**
5. **What are your big dreams and goals?**
6. **What do you want to know more about?**
7. **What do you love?**
8. **What do you struggle with?**
9. **What are you feeling?**
10. **Anything else you want to add?**

JUMP TO ANY QUESTION YOU WANT, WHEN YOU WANT

1. **What are you currently doing?** At work. At home. In your personal life. Write down the good and the bad. The things that give you energy and the things that drain it—and everything in between. Sometimes it's a clue to what you could be pushing into. There could be something awesome sitting right under your nose. If you took it off autopilot and spent 100 days focusing on it, giving it another go. Or it could be something you intentionally take off your plate so you can focus on your 100 Day Project.

- Social media manager.
- Fathering 2 kids.
- Volunteer at Creative Mornings.
- Running the AV team at church.

THESE ARE EXAMPLES

WRITE YOUR ANSWERS HERE

2. **What do you want to get done?** Some things aren't glamorous or fun or exciting, but you really want to get them done. And a 100 Day Project is a great framework for these kind of things.

 - Get in shape.
 - Update my personal branding.
 - Renovate my house.
 - Build my website.

3. **What do you want more of in your life?** Be honest here. What do you wish you had time to do? What experiences and objects do you want in your life? When you begin to add what you do want, what you don't want will automatically get pushed out.

SOMETIMES SLOWLY AND OTHER TIMES ALMOST INSTANTLY

- I want to read more.
- I want more chill time.
- I want more adventure.
- I want to play more music.

4. **What are you good at?** Some of the best 100 Day Projects are when you intentionally spend time doing what you're already good at. Maybe you've lost your passion for this thing. Or you've plateaued. Or you don't get much time to do it anymore. Or, maybe, you forking love it and do it as much as humanly possible. It could be part of your job, an old career, a hobby, or some personal thing.

- Yoga.
- Stencil art.
- Making kombucha.
- Animation and Motion Design.

5. **What are your big dreams and goals?** What do you want to be good at?
 Where do you want to be? What seems crazy-impossible to you? Spending
 100 days moving toward, or learning about, those big things can be one of
 the best uses of your time.

 - Build a cabin.
 - Be a passenger in space.
 - Become head of animation at Pixar.
 - Become a full-time surf photographer.

GO BIIIIG
IN THIS SECTION

6. **What do you want to know more about?** What do you want to learn? What are you curious about? It could be work-related. It could be a hobby. It could be a geeky thing you're into. It could be something related to what you're good at.

- 3D design.
- Drone photography and cinematography.
- Vertical gardening.
- Wim Hof's breathing techniques.

7. **What do you love?** The answers to this question make for great subject matter when combined with other things—especially if you're learning a new skill. If you're curious about 3D design and love donuts or skateboards, combining those two things into a project would be super interesting and inspiring.

- Trying new restaurants.
- Sailing.
- Scandinavian architecture.
- Dutch bicycles.

8. **What do you struggle with?** Something you want to get better at. Something that frustrates you about yourself. Something you wish you could change. Something you're scared of. Addressing these kinds of things in 100 days can make you feel a lot better about yourself.

 - I struggle with perfectionism.
 - I want to stop comparing myself to others.
 - I find it hard to stick with anything.
 - I'm terrible at staying in touch with friends.

9. **What are you feeling?** About what? And why do you feel this way? This can lead to a project that addresses a feeling. Or to one that's fueled by one.

- I'm angry with how little the world is doing about destroying our planet.
- I'm overwhelmed with social media.
- I'm overboard-pumped about moving to New York.
- I'm feeling refreshed by silence.

THE ANSWERS YOU WRITE HERE MAY LINK VERY WELL WITH THE EXERCISE ON PAGE 48

10. **Anything else you want to add?** This is stuff that doesn't fit into the other 9 sections. Let your imagination run wild. Don't restrain yourself.

- Meet a sultan.
- Get a famous songwriter to write songs for me, and then get them professionally produced and mastered.
- One-week silent retreat.
- Travel to another continent in a ship.

THEY CAN BE WEIRD!

Once you've got a bunch of project ingredients you can begin combining them into possible project ideas. Scan your list of ingredients and begin putting them into the following structure: **What if I _____ for 100 days?** Check out this "What if I" list of possible project ideas an example.

INGREDIENTS:

I WANT MORE EXPERIENCES

I'M GOOD AT MAKING THINGS

I STARTED BUT NEVER FINISHED ARCHITECTURE SCHOOL

THE SIMPLE LIFE

WOOD

I LOVE MY KIDS

I'M CURIOUS ABOUT MAKING KOMBUCHA

SKYDIVING!

BANKSY

I LOVE CABINS

I WANT MORE EXCITEMENT

KITE SURFING

I WANT TO LEARN HOW TO MODEL 3D

FEELING BORED

TURN YOUR INGREDIENTS INTO IDEAS

POSSIBLE PROJECT IDEAS:

TURN YOUR INGREDIENTS INTO IDEAS

- WHAT IF I SPENT MORE TIME WITH MY KIDS FOR 100 DAYS?

- WHAT IF I SPENT TIME MAKING KOMBUCHA WITH MY KIDS FOR 100 DAYS?

- WHAT IF WE SPENT TIME DOING CRAZY NEW THINGS FOR 100 DAYS AS A FAMILY? WE COULD GET THE KIDS INVOLVED IN IDEATING.

- WHAT IF I LEARNED 3D FOR 100 DAYS?

- WHAT IF I LEARNED 3D BY MODELLING AND RENDERING EXPERIMENTAL CABIN DESIGNS FOR 100 DAYS?

This is where you get to have fun. Complete the sentence by combining project ingredients. Mix and match. Make multiple combinations. Go from normal and sane projects to wacky and weird. Write it all down—even if it sounds ridiculous. Because when it's down on paper, your brain can comprehend and rearrange and try new things. Often times, as you write down one idea, another will pop up. If you're trying to do all this in your brain, you'll get stuck—your brain cannot hold tons of short-term information *and* think creatively. As you do this you'll probably begin to feel the excitement building. And you're bound to think ahead and sideways and then backward. Your thoughts may be all over the show.

"I love cakes. I want to do a cake project. Ooooo. Maybe I could draw cakes? And bunnies! What if I draw 100 bunnies? Eating all my favorite types of cake?"

Let the ideas flow and write it all down.

At some point you'll have *a ton* of possible *What if I* project ideas.

What's standing out and captivating you and making you excited?

What ones do you really really want to do?

Highlight or underline or draw crazy circles around these ones.

IF YOU NEED MORE SPACE
FOR IDEAS, FLIP TO THE
BACK OF THE BOOK

What if I _____ for 100 days?

EXERCISE 2

Discover the Reasons

Now that you have some possible 100 Day Project ideas highlighted, it's time to examine why you want to do them. "Do I need a reason—beyond the fact that it just forking excites me?!" Possibly not, but excitement is often a temporary emotion. And when it dips or fizzles out, often times so will your project.

Knowing *why* you're so forking excited about doing your project will sustain you when things get tough or boring. You'll be able to return to this reason and remind yourself of why you wanted to do this project in the first place. It often transports you from the trenches of daily work to a bird's eye view of your project. You're able to see where you're going again.

Select your favorite project ideas (maybe three to start with) and create a mind map of reasons you want to do that project idea. For each reason ask yourself why again. And again. Until you discover a reason that makes you go "YAAAAAAAS! That's it. That's why." You want to get past the "to get rich," "because it helps people," and "because I like it" reasons. Go deeper. What does that enable? What does that allow? What does that allow you to contribute? Why is this important to you? Why does this light you up? Why, exactly? You want a reason that's authentic. Check out this mind map as an example.

SO MANY QUESTIONS!
BUT QUESTIONS LEAD TO ANSWERS!

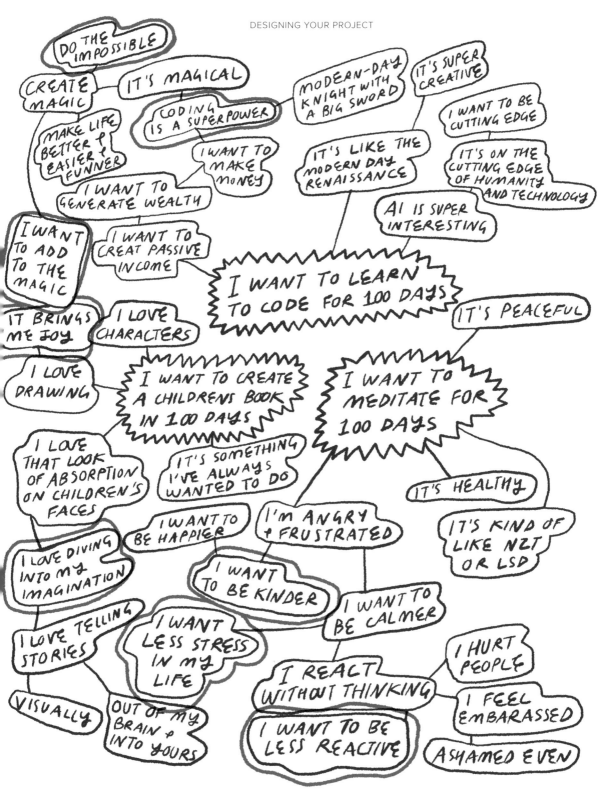

That mind map could give you the following reasons for the following projects:

- I want to learn to code for 100 days **so I can add to the magic in the world.**
- I want to meditate for 100 days **so I can be kinder to people, less reactive, and less stressed.**
- I want to create a children's book in 100 days **because telling stories visually ignites my imagination and brings me joy.**

Now it's your turn. Get to the bottom of why you want to do your favorite project ideas.

Once you have a mind map of possible reasons, highlight the ones that resonate with you most—or circle them like a crazy person. This part of the process often elevates some projects and sinks others. Why you want to do something is a big factor when working on it for 100 days.

Sometimes you'll discover toxic reasons for the projects you're considering. Finding this type of underlying motivation sucks. But it does mean you're learning about yourself before you've even started your project. When this happens, there are a few things you can do:

- **Cross it off your project list.** This feels good. You've completed something. Move on. Get onto something else.
- **Try to find better reasons.** Sometimes the real reason *is there*. It's just that a toxic reason has masked or warped the real one.
- **Ask people close to you what they think your underlying motives are.** Sometimes you're too close to yourself to know what makes you tick.

COMING BACK THE NEXT DAY OFTEN HELPS

Why do I want to do these projects?

ANYTHING WORTH DOING IS WORTH DOING BADLY

—G.K. CHESTERTON

EXERCISE 3

Acknowledge Your Constraints

With some possible project ideas and some reasons why you want to do these projects, you can begin to fit them into your life. And this is where tons of people get stuck.

Too many people never take a single step toward the life they want because they believe they have too many constraints. Or that *their* constraints are too big. They don't have enough time. Or they *only* have time on the train. They don't have enough money. Or any money. They don't have the right equipment. Or software. Or knowledge. Or connections. Or staff. Or team. Or or or.

Don't treat constraints as excuses for not doing *anything*.

BUT PERFECT PROJECTS DON'T EXIST ANYWAY

By working within your constraints, your project won't be perfect and it probably won't turn out exactly how you dreamed it would. But it will be something.

Don't overestimate the power of doing *something*.

You may be someone who wants to make Hollywood-style films for your 100 Day Project. But all you have is an old iPhone and no actors. No gaffers. No film crew. Without acknowledging *and* working *within* your constraints, a few things could happen:

You get sorely disappointed and disillusioned with the outcome of your project. You may think *you* suck, that it wasn't worth it, or that this thing you tried for 100 days is *the worst*.

You put yourself under intense pressure to achieve. Too much pressure maybe! Which would most likely set you up for failure and burnout.

You never attempt *anything*. Because you'd know it wouldn't live up to what you have in your head.

When you do acknowledge *and* work *within* your constraints, a few things begin to happen:

You learn the value of hard work. People who have less constraints often have less constraints because they've been working *within* constraints for years.

You start focusing on what's really important. An amazingly produced movie with a terrible story will never compare with an amazingly told story around a campfire.

You take action. Because you know perfection isn't an option, mediocrity it is. But the good thing is that mediocrity plus action leads to far more than perfection and no action.

You do more. Your productivity and efficiency increases. With fewer resources and less pressure, you can experiment more, produce more, and play more.

You get better quicker. Because you're doing more, you learn, iterate, and improve a lot quicker. Quantity leads to quality.

You gain confidence. When you get better, your confidence grows. Which means you try new things and take risks.

Constraints can be a blessing in disguise. And if you don't have many, use it to your advantage or intentionally set parameters that act like constraints (see Exercise 4).

In the case of an iPhone Hollywood-style cinematography 100 Day Project, working within constraints *could* look like filming a short film where a lot of monologging happens. You could work on your film for 1 hour each day— working on a script each day until it's done. And then you could move onto planning, location scouting, filming, etc. when each subsequent part of the project is done.

CONSTRAINTS ACTUALLY BREED CREATIVITY

Now, this is where you take your crazy, lovely, ambitious project ideas and turn them into 100 Day Projects you can fit into your life—with all its constraints. It's where you reduce the pressure, adjust your expectations, and work within your constraints. It's where you create a project that's possible to do with what you have. You *can* make your project work. It *will* need to be adapted. And yes, the constraints will change it. But you can begin to take hold of what you want in your life. Make riffs on your commute. Learn a new language while you shower. Pay a virtual assistant to book you crazy things to do each day. Make YouTube videos with your phone. Do yoga in the public park during your lunch break.

Break the norms.

Don't wait for things to be perfect before starting.

Make it work.

Do something.

What are your constraints?

TIME? MONEY? LOOKS? EQUIPMENT? SKILLS? RACE? LANGUAGE? TALENTS? GENDER? LOCATION? SUPPORT? STATUS? KNOWLEDGE? NETWORK? PERSONALITY TRAITS?

WRITE YOURS DOWN

How do your constraints change what your projects look like?

EXERCISE 4

Define Your Parameters

Now it's time to define the parameters for your project. "How are parameters different to constraints?" you may be asking. Well, in my opinion, parameters are things you choose. They're far easier to control and manipulate than a constraint. Your project's medium. The subject each day. The equipment you use. The number of words. When you do your project. How long you do your project for each day. Dr. Seuss wrote *Green Eggs and Ham* with a 50-word vocabulary— that was a parameter he chose to work within. *IMPRESSIVE HUH?*

With parameters, you can enhance and clarify your project. They can be self-imposed constraints, rules, or details that you use to shape your project into something you want it to be. Your project could be a short, fun, intense thing each day. It could be a low-pressure, relaxing thing each day. It could be a challenging thing each day that leads to the completion of a bigger thing. It's with parameters that you put the cherry on top of a project that will usher in more of what you want in life. It's with parameters that you create a project you're more likely to return excited to each new day. One that generates momentum. One that intrigues you. One that keeps your interest piqued. One that won't feel like a boring task. One that's easier to fit in.

Imagine your project was meditating in a new place for 100 days. Here's the same project, but with different parameters:

- Do an unguided meditation for 1 hour every day in a new city at 6 a.m. for 100 days.
- Do a guided meditation using an app for 5 minutes every day during the week, for 100 days, in a new location I can walk to during my lunch break.

In both variations, you'd still be adding more of what you want into your life (peace and novelty) but doing it at a very different scale.

With that in mind, let's get into some possible parameters. You can write down some thoughts on page 58 while you go through them.

Duration. How long you spend on your project each day is one of the most important decisions you'll need to make. You may already have tons of stuff going on in your life. Or you may have the freedom to spend all day on your project. You'll have to balance what you want to do with what you can realistically do and with what is wise to do—especially with the time you have.

What. When you can decide what you're allowed and not allowed to do, it's a great way to foster creativity. Are you only going to do mantra meditation? Are you only going to photograph black men in their 80s? Are you only going to use red and blue? Are you only going to use Comic Sans? What are you doing? What are you not doing? *DEAR GRAPHIC DESIGNER: I DARE YOU TO DO A 100 DAY PROJECT WHERE YOU ONLY USE COMIC SANS!*

How. This could be the process you use. The equipment. The medium. With your left hand. With your pinhole camera. With what can fit in your bag. This parameter can increase the fun and challenge.

When and where. After breakfast. During lunch in the park. In the afternoon at my local coffee shop. Deciding on a place and time of day helps you create a routine. It becomes an event or appointment in your day, rather than something you need to fit in. Add it to your calendar to make it a *thing*.

When it comes to parameters, reducing the number of decisions you need to make and things you need to worry about on a daily basis will allow you to focus on what your project is all about. I suggest keeping some parameters tight (or fixed) and others loose—depending on what your project's focus is. Your project can have two types of parameters: *THIS CONCEPT IS GOLDEN FOR 100 DAY PROJECTS*

CONSTANTS → *PARAMETER TYPE 1*

What is going to be fixed, static, or pre-chosen? Duration is an easy one to make into a constant. As is when and where. If you're wanting to get better at portrait photography, taking pictures of people will be a constant. Maybe even the same person. If you want to design cabins using 3D software, using the same 3D app would be a constant. A constant can also look like limiting the use of certain things. What are you intentionally not using, or using less of? Certain colors? Certain methods? Want to get better at Adobe Illustrator? Limit your use of Adobe Photoshop for 100 days. Want to get used to working on an iPad? Limit your use of your Mac for 100 days.

VISIT TAPTAPKABOOM.com
FOR RANDOM WORDS

PARAMETER
TYPE 2

VARIABLES

What is going to change on a daily basis? And how are you going to decide how it changes? Which song will you sing? What will you sing about? Will it be the same song sung in a different way? In what genre will you sing?

If your project was about confronting perfectionism, you could draw a random word (a variable) for 3 minutes each day. With your left hand. During your lunch break. Using the sharpie on your desk (constants). And then give it to a stranger on your commute home (another variable).

If your project was about practicing using watercolors, perhaps you could paint the fruits in your fruit basket (a variable) for 30 minutes after lunch (constants). It will be fruits for 100 days. But they'll change. Even if no one in your house eats fruit, they'll still change—they'll rot, change color, and change shape.

If your project was about practicing breathing techniques, you could use 30 minutes of your lunch break (constants) to practice a new breathing technique (a variable). Each new technique could be at a different location (another variable).

What parameters can you add to your project? Write down some ideas and how they would change your potential projects from page 47.

THIS IS THE LAST EXERCISE IN THIS CHAPTER!

EXERCISE 5

Choose Your Project

Now it's time to choose your 100 Day Project. It may be your first 100 Day Project. It may be your third. Maybe you've been back and forth between constraints and parameters and ideas. Maybe you knew what your project was going to be from the moment you spotted this book. Take a look at your project options with constraints and parameters added, with reasons written down. Do some tweaking if needed. And then choose. This could take an hour. And it could take days. There's no need to rush—but don't stall!

What's exciting you? Can you hear your shovel clinking against a treasure chest?

What is your 100 Day Project?

Do I need to do a "creative" project?

While browsing the Internet, and especially social media, you'll see tons of visually appealing "creative" 100 Day Projects. Drawing, designing, painting, sewing, animating. Why is this? There are 3 reasons. Firstly, "creative" projects *do* change your life, and they're easy to do—5 minutes of doodling every day is *really* easy to do. Secondly, most "creative" projects are clearly *creative*— intentional acts aimed at making life more of what you want it to be. Thirdly, "creative" projects are often visual. And the Internet is suited to visual content. This makes them easy to share, easy to salivate over, and easy to be inspired by.

But you don't know what *isn't* being shared, and how many "non-creative" 100 Day Projects are being done. *THERE COULD BE THOUSANDS*

So, do the project you want to do. Don't give into doing something "creative" just because that's all you *can* see. Be *creative* by being intentional about what you do for 100 days.

Can I merge what I'm currently working on into a 100 Day Project?

Yeah. Of course. This makes a lot of sense. Rather than having 2 projects on the go (or more), use the format and structure of a 100 Day Project to work on what you've currently got on your plate.

SO MANY!

What types of projects are there?

The type of project you choose will largely depend on what you want more of in your life, or the person you want to become. But here are some ideas.

Learn something new for 100 days. Either for your career or personal life. And either something totally new that you're curious about or something that's new in a field you're currently invested in. Wedding cake design. Building websites. Voice User Interface design. 3D animation. Meditation. Yoga. Calisthenics.

Get better at something for 100 days. This may be something you're already pretty good at, something you want to focus on, or something you started once and want to pick up again. Swimming. Playing the piano. Your illustration style.

Have fun for 100 days. Putting googly eyes on something for 100 days. Dancing. Making up raps. Pulling pranks. Letting an audience decide.

Warm up for 100 days. This could be a 5-minute painting before you get into your graphic design work. Stretching. Making up a riff. Generating 10 ideas. Small exercises to get your brain working, or your body ready.

A linear project. Writing a book. Creating an app. Launching a business. Each day may look a little different. This is a good one to set aside a certain amount of time for each day.

Connect with yourself for 100 days. Meditating. Journaling. Self-care with imagination. Walking. Exercising. Yoga. Breathing. Facing your fears. Gratitude.

Connect with others for 100 days. Writing letters to friends. Making greeting cards. Sending emails. Making videos for your kid for when they turn 18. Visiting the elderly. Visiting the young. Visiting prisoners.

Avoiding something for 100 days. No alcohol. No social media. No smoking. No drugs. No porn. No games. No Internet. No car. No sugar. No takeout.

Prototype a life change for 100 days. New career. New diet. New wardrobe. New friends. New city. New lifestyle.

Of course you can mix and match; design a project that fits into *several* categories.

What makes a good project?

Someone else's 100 Day Project may look amazing. Someone else's 100 Day Project may go viral. Someone's else's project may make them famous or stinking rich. That someone *may be you.* BUT MOST PROBABLY NOT

But that's not what makes a good project.

A good project is one where you pursue the change you want to see in your life. It may be minuscule. It may be massive. And it may lead to all kinds of outcomes. Like fame, money, and attention.

But it's not just those things. We could all do with being more in shape, further in our careers, eating healthier, creating more, learning a range of new skills, connecting with our bodies, revitalizing our souls, doing good, traveling, pursuing our dreams, building relationships. The list goes on. There's always going to be tons of stuff you *could* be working on, or even should be working on.

A good project captivates you.

It's interesting.

You *want* to do it.

It's a challenge. But not *too* challenging.

You spend enough time on it. But not too much time.

It has enough variance. And enough monotony.

You can do it for 100 days.

Something that's just right. WHICH IS WHAT THIS BOOK HELPS YOU PICK

Unfortunately, only time will tell whether it *was* a good project.

What if I'm struggling to choose my project?

If you're struggling to make up your mind, don't worry. It's a common thing! Here are some different thoughts and ideas about deciding on a project to consider. See which ones speak to you. ──▶ *PROBABLY NOT ALL OF THEM*

This 100 Day Project is for now. For the next 100 days. What does *that* project look like? This could change in 6 months. Or a year. Or in 10 days. Or in 3 months. And if it changes while you're doing your project, you're allowed to adapt and pivot.

What can you fit in? Right now. What *will* you be able to do for 100 days? What do you think you'll be *able* to do? Daydreaming about what you *could* do if you had _____ won't help. Do this project within the constraints of your current life.

You cannot do *everything* for 100 days. There are going to be more occasions to do a 100 Day Project. So don't overburden yourself.

It can be simple or small or basic. You don't have to make it big or complex or intense. And you can always level up your project as it progresses. This may look like 10 minutes of learning to play the piano with an app every day. And 96 days later it could look like composing your own song. But it could stay simple the whole way through. It could be something to get you warmed up. It could be practicing breathing. Or writing down what you're grateful for each day. Or waking up 20 minutes early each morning.

Which one of your project options could you *not* not do? Which one is calling to be done? Which one would you regret not doing? There are always tons of things we could do, want to do, should do. But if you could only do one project before you die, which project would it be? *TOUGH QUESTIONS HUH!?*

Do the one that helps you grow most. Do something that makes you able to handle more. That makes you stretch and learn the most. One that gets you out of your comfort zone. Do something daring. Which project is this for you?

#100DAYSOF10DAYPROJECTS
SOMETHING LIKE THAT

Try out a project before committing to 100 days of it. Or change your project every 10 days for 100 days. This way you can do all of them and see which one works out best. Sometimes, comparing things to one another helps you decide which you prefer.

Set yourself a broad 100 Day Project. One where you try all kinds of things. One that's flexible. One that changes often. This allows you to experience all kinds of things. Just show up for 100 days and see what happens.

MORE FUN
IS ALWAYS
A GOOD THING

Make it fun. The funner it is, the more likely it is that you'll stick to it.

Learning foundational skills never go to waste. You can build tons of other things on them. Learning to code. Presenting in front of an audience. Graphic design. Leadership. Healthy eating. Sleep.

Discuss your project options with friends or family. Listen to what they have to say. Sometimes you're too close to yourself. Sometimes you need to get out of your head and let other people, who know you, in.

What's meaningful for you? What will you do regardless if no one sees or likes or comments on it? What's going to be intrinsically gratifying? This question often takes people by surprise. Do you want to do something to look cool, or knowledgeable, or creative? Or do you want to do something because *you* actually want to do it? THIS QUESTION ALWAYS HELPS ME.

Don't be trapped by your past. What you did last time. What you're known for. What you and others expect of you. Let that stuff go.

Pave the way as you go. Try something where you don't know where you'll end up. Where you don't know what it looks like. Where the more you explore, the more pathways and alleyways and options and forks in the road appear. Where you discover what you do and don't like on the way.

Just start one. Any one of your projects. You'll learn so much and figure out what you actually want along the way. Rather start one than stand at the crossroads forever. What you do isn't necessarily the goal. It's everything else that comes because of doing *something* for 100 days.

What if my last project was a huge success?

EVERYONE'S DEFINITION IS DIFFERENT

Often, when we find *success* we feel like we need to replicate replicate replicate. Instead of doing what we want. Or what we need. Something new. Something weird. Something exciting. Something past-you wouldn't have cared for or thought you'd *ever* do.

Don't let your past success prevent you from more success, new success, or different success.

You may have received a ton of attention during, and because of, your last 100 Day Project. And you're scared that if you veer off and do something *different* that you'll lose that attention. Maybe you'll gain more with this project. Maybe not. But with this new project there isn't a slow creative death on the cards.

Why was your last 100 Day Project a success?

No matter why it *was* successful, what matters is what you choose to do for *this* project.

That successful project was *last* time. Be a beginner again. Treat this project as if it were your first. As if you didn't know what success was. Treat it as day one. Don't worry about how this project will measure up to that one. Don't be stuck in what your past self has done. Don't be stuck in what you expect yourself to do.

What's going to make you feel alive now?

What's exciting you now?

Where do you want to grow?

What would be scandalous for you to do for 100 days?

What do you want right now?

EXPLORE SOME OPTIONS HERE

Allow your project to be messy and imperfect and unsuccessful. Give it room to breathe and grow and show you different things than the last one did.

How do I choose my subject matter each day?

This question only applies to projects where the subject matter changes each day. Maybe you're drawing for 100 days, but what to draw? Maybe you're creating 3D models, but what to model? The subject you choose every day can have a big impact on your project. And if you're not careful, choosing your subject matter every day can become stressful. It may even be the hardest part. Ideally, you want to make it easy to do your 100 Day Project each day. So, doing something where you don't have to come up with a new idea each day is perfect. I recommend one of four ways of choosing your subject matter (or using a combination of them):

Choose from an existing database. This way of choosing is a lot easier, and you don't have to do a bunch of research. If you're painting a different moth each day, have a moth reference guide handy. If you're writing a song about a pirate each day, have a pirate anthology on your coffee table. If you're drawing different leaves, get that big book of leaves. *I WOULD SERIOUSLY LOVE SOMEONE TO MAKE SONGS ABOUT PIRATES!*

Choose from externally generated content. This is where something else gives you subject matter options to choose from. You could use a random word generator, a newspaper, or your audience, to come up with subject matter. This way, there are options, but not limitless options. *FIND ONE ON TAPTAPKABOOM.COM*

Choose what you love. If you love bunnies, draw bunnies—all different kinds in all kinds of poses. If you love landscapes, photograph landscapes. If you love hip-hop, learn to play hip-hop songs on your piano. When your subject is something you love, it motivates and excites you.

Choose from ideas you've captured. If you do want to come up with your own ideas, make it easier on yourself. Every time you have an idea of what you can do for one of your 100 days, write it down. Store it up. And when your supply of ideas is dwindling, spend some time brainstorming. When you sit down to create, you want to create—not have to ideate first.

Can I pick an outcome-based goal to achieve for my 100 Day Project?

You may feel pressured to focus on setting an outcome-based goal. "What's that?" Something like gaining 1000 subscribers on YouTube or losing 10 kilograms in weight. Those are admirable goals. And maybe they're possible to achieve in 100 days. But I don't advise on choosing things that are outside of your control. You may try all the things, and do really well, and still not achieve your goal. You may be a genius but feel like you failed at your 100 Day Project because you didn't hit your outcome-based milestone. Even if you do reach your milestone, *getting there* is what you spend a majority of time on. So, have a blast *doing* the actual thing!

For any outcome-based goal, ask what the steps are that could lead to that goal. That's what you should make your 100 Day Project about. The things you *can* control. The things *you* can do. Focus on the process. Not the output.

Maybe your goal for your 100 Day Project is to run a marathon in 4 hours and 20 minutes or less. That's an outcome-based goal. Ask how you'd run faster. Training. Diet. Mindset. Focus on those things for 100 days. Eat a certain way and train a set amount every day. Those things are in your control.

Maybe your goal for your 100 Day Project is to get 10,000 Instagram followers. That's an outcome-based goal. Ask what leads to growth on Instagram. Engagement. Interesting content. Community. Consistency. Focus on those things (maybe even one) for 100 days. Maybe your 100 Day Project is creating something interesting for your audience every day. You can control that.

What is your outcome-based goal?

What leads to that goal?

And what repeatable action can you commit to that will get you closer to reaching that outcome-based goal?

GET YOUR IDEAS OUT OF YOUR MIND

Make this your primary goal. Celebrate what you put in. Celebrate showing up. And when you do get something out, celebrate it too, but don't focus on it.

What if someone has already done *my* project?

Listen, everyone says it's all been done before and there's no such thing as a unique project. Bollocks. It becomes unique when *you* do it. No one has already done *your* project. Not even you could do your project exactly the same again. In the same way. In the same time. And get the same things out of it.

There will always be *something* different between your 100 Day Project and someone else's—no matter how many things are the same or similar. You have a different magic. And you'll do it for different reasons.

Don't worry about doing the same thing as someone else. I mean, you're already doing a 100 Day Project, which is what thousands of people have already done— maybe even millions. If we didn't do something because it had been done before, we wouldn't have done much as a species.

You are different. You have a different personality. And different characteristics. Different dreams and goals and desires. You have a different life. Where you are in life is different. Where you are in the world is different. Where this project will take you will be different. You're on a different journey. Even if the first 10/50/100 days look the same, each day represents an opportunity to veer off, to be different. Starting in the same way doesn't mean you'll end in the same way.

If all of those reasons aren't enough, make your project different in some way. Add to it. Remove from it. Combine it with something else. Share it differently. Start from where they left off. Stand on their shoulders.

Maybe you *want* to copy what someone else did. That's okay. Do it. Mention your sources. Tell people who inspired you. It will still be yours. Just like when you follow a recipe, the cake at the end of the day is yours.

Do this project for *you*. And enjoy *your* cake.

I BET YOU FEEL LIKE CAKE NOW HUH?

EVERYTHING
HAS BEEN THOUGHT OF BEFORE, BUT THE PROBLEM IS TO THINK OF IT AGAIN.

—JOHANN WOLFGANG VON GOETHE

How much time should I spend on my project?

Of course we all know you're spending 100 days on your project. Duh. That part is a done deal. Now the tricky part is choosing how much time you spend on your project *every day*.

Whether your schedule is packed or you've got oodles of time to spare, deciding how much time to spend on your project is important. It can make or break it.

Spend a *Goldilocks* amount of time on your project each day. Not too much. Not too little. Just right. Negotiate with your brain until it says something like, "Yes I *can* do that!" But maybe with a slight hesitation beforehand. Set realistic expectations. But make it fun and challenging. You could also set yourself both a minimum and a maximum amount of time. The minimum is an easy way to get started. The maximum is so that you don't work for 16 hours straight and never feel like working on your project again.

In general, the more time you have the more pressure you put on yourself to create something amazing. You become critical. You second-guess yourself. You spend more time umming and ahing. You diddle-daddle. You start over. You lose energy and momentum. You take tons of breaks. You clean the toilet. You get the point.

Spending less time, in most cases, will serve you and your project better than spending more time. You often get as much done with less time. You go into action-mode. You focus. There's energy. There's excitement. There's challenge. And the pressure to do something *amazing* is reduced.

As you progress through your project, reassess what a Goldilocks amount of time looks like for you.

WHEN IN DOUBT, GIVE YOURSELF LESS TIME

What if I'm traveling during my 100 Day Project?

LUCKY YOU!

If you know you're going to be traveling before you begin your project, think of how you can make your project mobile. 100 days is a long time. To only be able to do your project when you're at home can be problematic. Tablets, phones, hand-held recorders, notebooks, and things like that help a lot.

Acknowledge traveling as a constraint and make mobility a parameter for your project.

If you're reading this chapter and not planning on traveling, consider making your project mobile anyway—it means you can do it wherever and whenever.

Can I do more than one project at a time?

Sometimes you really want to do multiple things at the same time. I get the appeal. I get the reason. You *could* try. There's no rule against it. Whether it's *wise* is the real question. I mean, doing one 100 Day Project is hard enough—doing two at the same time is extra tricky. From experience, you cannot do *everything* all at once. *And* do it well. That's a shotgun approach. And it often won't work. Focusing on everything is like focusing on nothing. Like a company *YOU'VE SEEN THESE COMPANIES RIGHT?* that specializes in photography, graphic design, animation, plumbing, and photocopier repairs. There are plenty more 100 Day Projects that you can do in the future. Don't try fit everything you want to do in your life into the next 100 days—it's a recipe for all kinds of not-good-stuff.

Focus on one thing and do it well. Then, when your project is over, get onto the next thing. If you *really really* want to do two projects, perhaps make them both 50 day projects, do one after the other, and call the combination a 100 Day Project.

THERE ARE SOME
IMPORTANT CHAPTERS
HERE. VITAL EVEN.
TONS OF PEOPLE LET SHARING
GET IN THE WAY OF THEIR PROJECTS

76
Who should I tell about
my 100 Day Project?

78
Should I share my
100 Day Project?

SOME
GEMS →
HERE
81
What are the benefits of
sharing my project?

83
What are the benefits of
not sharing my project?

84
How do I overcome the
fear of sharing my work?

88
What if my project is
hard to share?

90
How do I share my
100 Day Project?

90
What if no one comments
or likes what I'm doing?

91
How do I respond to good
and bad feedback?

I WANT TO STAR *
EVERY CHAPTER

Who should I tell about my 100 Day Project?

Many people create a post on their social media profiles, telling the whole world that they're going to do a 100 Day Project, and that they've started, and they post each day for all to see.

That's awesome. You *can* get a lot of feedback and encouragement this way.

But, nowadays, just because you put it out there doesn't mean *everyone* will see it. And if you want *someone* in particular to know about it, it's best to tell them directly.

But who exactly do you need to share your project with? There are some types of people who will make your project better, easier, or funner, if you share it with them.

Partners. If you have a partner, tell them about your project. They're often the person who helps you stick to your 100-day commitment the most. When you say, "Let's watch a movie!" They'll ask, "Have you done your 100 Day Project today?" Or if you're avoiding sugar, they'll not buy sugary things. In fact, they may join you in your 100 days of sugarlessness. I call these people your enablers. Tell them about your project to get them on your team. Do it "together." It's hard when someone you spend a lot of time with is not working with you, or even working against you.

Coconspirators. The next person you may want to tell is someone who's like a coconspirator. Someone who's on the same level as you. Someone who's excited for the same things as you are. Someone who may even have done, or will do, the same kind of project as you. A business partner. A colleague. A friend. It may even be your partner/enabler. Coconspirators stoke your excitement and give you advice and point you in the right direction. The questions they ask and the encouragement they give mean more because they're on a similar journey.

NOT TO BE CONFUSED WITH COCOON PIRATES

Hero/coach. The final person you may want to tell is a mentor or hero or coach or someone you look up to. Tell them about your project, ask for feedback, and send an occasional update. Be nice. But don't overstay your welcome.

Who are you going to tell about your project?

IT'S CRAZY AND MAGICAL HOW EASY IT IS TO SHARE OUR WORK

Should I share my 100 Day Project?

There are millions of 100 Day Project posts on social media. Millions. And tons get added to that number every day. It looks as if *everyone* is sharing their 100 Day Projects. Everyone! And there are some good reasons to share. And some good reasons not to.

For some people, sharing their creative work comes naturally. Some people have worked hard to be comfortable and confident sharing their work. But for many people, sharing their creative work is a monumentally huge thing.

I GET IT

They feel unqualified.

They feel like their work isn't good enough.

They're shy and unsure.

They feel like the world is going to judge them—and find them unworthy.

Or they feel like no one will pay them *any* attention.

They're scared of failing. Or of wasting their time.

Or of not meeting their expectations—especially if what they shared before was wildly popular.

Some people get hot and bothered thinking about sharing their creative work.

Some get freaked out.

Some feel like they're adding to the overwhelm.

Some feel like their posts will get lost in the algorithm.

And still others share their work because, well, everyone else does. "Isn't that what we're told to do?"

But you don't *have to* share.

YOU'RE NOT ALONE IF THIS IS YOU

SHARE IN A WAY THAT YOU'RE COMFORTABLE WITH

You could do your 100 Day Project in secret. You could share every other day. Or every 5 days. And you don't have to share *all of what you create*. You could share the interesting bits, or the process, or snippets of what you're working on.

Sharing isn't a requirement. No one is forcing you to share. And you don't need permission from anyone *not* to share. You decide if you share or not. You decide who you share with, where you share, how often you share, and what you share.

Now that we've got that out the way, and the pressure is off, let's chat about sharing. The act of sharing holds different purposes for different people. Sometimes sharing is merely documenting what happened. Sometimes it's to show the end result. Sometimes you want to share the process. Sometimes you share to invite conversation, feedback, and criticism. Sometimes you share to educate.

What are some reasons you do and don't want to share your project?

How could you change what and how you share to achieve this purpose?

Don't share just because someone told you to.

Don't share because everyone else is doing it.

Don't fall for that bollocks.

Share intentionally and wholeheartedly.

Or not at all.

Maybe you don't want to clog up your feed? That's okay. Start a new Instagram account. Maybe you don't want to share with the whole world? Share with 1 or 2 people over email, WhatsApp, or text. You could even snail mail your pieces to a friend. Maybe your project is personal. What part of it *can* you share with people?

If you're unsure whether to share or not, try it out and see what happens. Keep checking in with yourself, asking why you're sharing, what's working, what's not, and adjust what you need to. You can even test a few sharing ideas out—you don't have to stick to one format your entire project. You're 100% allowed to change your mind.

Only you will know how sharing (or not sharing) your project affects you and your project.

THERE'S MORE SPACE
AT THE END OF THE BOOK
FOR YOU TO WRITE IF YOU
NEED IT.

THERE'S SOME REALLY GOOD STUFF IN THIS CHAPTER

What are the benefits of sharing my project?

I'm a big fan of sharing 100 Day Projects—especially on a daily basis. Here's why.

It keeps you accountable. You know someone is expecting you to create and share—you don't want to let them down. Knowing this on any given day is often the tiny push you need to start creating. And once you start, the act and joy of creating—not the expectations of someone else—keeps you going.

You create conversation. When you share what you create, you invite others to have a part in it. It's not self-promotion or marketing. It's not monologue. Your 100 Day Project becomes a conversation. It allows people to respond. To gush over your creation. To encourage you. To get angry with you. To cry with you. To challenge you. There are questions. And answers. You change because of it. Your project changes because of it. And so do other people.

You create community. If you share publicly, when you comment and discuss, you meet people from everywhere. People in similar stages of career or life. People with similar interests. Maybe people with kindred spirits. Or maybe someone awesome who lives a few blocks away.

It creates closure. There's always a temptation to do a little bit more work. To make your creation a little bit better. A little more perfect. But, when you share, it marks the day's creation as done.

You acknowledge your progression. Each day you create is another milestone reached. When you share, you get to acknowledge that and celebrate it. You intentionally created another something to make your life better. And when you see all your creations next to one another you begin to see how you've progressed. How you're getting better at something. How you're changing.

You influence the world around you. By sharing, you get to push 100 pieces of you and your project into the world. I know this is scary. It's being vulnerable. And some people won't care about who you are and what you share. But sometimes what you share will resonate deeply with others—even if it isn't *your* favorite creation. It may make their day. It may make them cry or laugh or think.

*THIS IS MY
FAVORITE
REASON* ↘

Your ego is humbled. Posting your project every day hurts a bit. Because what you're sharing often just isn't as good as you'd hoped. And you don't have the time to craft or compose perfect posts. It helps you relinquish the need for perfection and everything to be right. It reduces the pressure to be perfect that social media often puts on us.

You ease up on judging what you create. If you're like me, you'll often judge your work too harshly. You don't like it. You nearly bin it. In fact, you hate it. But, because it's one of your 100 pieces, you post it anyway. And someone loooooooves it. They're over the moon about it. They want it. They share it. It goes viral. And you're like, "I almost chucked that thing in the bin!"

*THIS MAY
NOT
HAPPEN
WHEN
YOU
SHARE*

It dismantles the idea of perfection. You begin to realize you don't need to wait for something to be perfect to share it with others. And then you begin to realize that perfection is subjective. All there is, really, is preference and taste and opinion. Some people will love what other people hate.

It thickens your skin. Sharing can be hard. Because we all naturally want validation. And sometimes we don't get it, or we get the opposite. People may say nasty things about what you share. Or maybe no one says anything about it. The more you're exposed to nasty bits of sharing, the more immune to it you'll become. If you get used to the haters and all the ugly things they say, you'll know it's part of the gig. It may even become a way to know if you're on track.

You become braver and more courageous. Because you're practicing posting stuff that often isn't perfect, and that often isn't your finest, and that people shoot down or ignore, you're practicing being brave. You're embracing your fear and posting anyway. That's some tough stuff to learn. But it's golden.

You create a name for yourself. What you share may lead to others asking you to do the same for them. Client work. Speaking engagements. Consulting. Collaborations. It may lead to the kind of work you want to do more of. Often times people have done a 100 Day Project that no one asked them to do—the one they've always wanted to do. They shared their work. They began getting queries to make *their* work for other people. This 100 Day Project can become your portfolio. You get known for something. You build your brand. And you may receive commercial interest.

What are the benefits of not sharing my project?

From my perspective, there aren't as many benefits of not sharing. But there are enough to seriously consider not doing it:

You save a bunch of time. Sharing is like a cherry on top. It doesn't make your creation, but it can add and compliment it. A little bit of work can go a long way when it comes to presenting and sharing your work. But it can take a lot of time. Lighting. Cameras. Accessories. Props. It can get all-consuming. Even 2 minutes may be too much for you. You could spend that 2 minutes creating!

SHARING CAN BECOME AN ART. YOU COULD DO A 100 DAY PROJECT ON SHARING

You'll avoid social media addiction. If you share on social media you *may* become addicted to how people respond. Do they like it? Did they comment? Who commented? How many views? I'm going to delete this post—it's not performing well enough. You may end up spending more time on social media than you do creating each day. You'll keep it pure, and all about the creation, if you avoid sharing on social media.

You'll avoid nasty feedback and deafening silence. If you share, what people say (or don't say) may affect your ability to create. Their words may sting. Their silence may hurt. And it may suck all the joy out of creating. Out of being you. Out of trying. Without sharing, you won't need to deal with this.

IF YOU CAN'T BEAT IT, AVOID IT.

You'll stay true to you. By avoiding sharing, what you create will only be for you. You'll be the judge. You'll create for the feeling it gives you. Or the benefits you get from it. And you'll progress because of insight you gain. You won't create for attention. Or popularity. Or likes. You'll continue to create work that you believe in and care about.

Rather sacrifice sharing than sacrifice your mental health. Rather ditch sharing than ditch your love of creating. Rather avoid sharing than avoid working on your project.

How do I overcome the fear of sharing my work?

I've been there. Scared to share my creative work. And once you're on the other side, no longer scared of sharing your work, you forget how daunting it is. To put yourself out there. To invite feedback and criticism. To potentially go viral or, conversely, to get no feedback at all.

Sharing your creative work is an act of vulnerability. I respect and applaud anyone who does it. Especially with new work. Especially when it's something you care about. Especially when it's something you've been working on for ages. Especially when it's something different from your usual. Especially when you know it will spark criticism and questions. Especially when you've never done it before.

Sharing is a big deal when there's fear involved. One of the best things you can do is acknowledge that fear. Name it. And then explain it. *DO THAT HERE* ⸺

When you write your fears down on paper, they take form. You get to see them for what they really are—without being aided by the murky shadows of your mind. They become something you can prod and poke and inspect. Their own entity, separate from you. They become something tangible you can deal with. Something you can fight against.

So, what exactly are you fearful of happening when you share your work?
Write about the worst possible version of your fear coming true. Spare no details.

With your fears written down, and without them swirling about in your head haunting you, you can begin to undermine them with logic, rational arguments, and truth.

Write down some logical, rational, truthful arguments to refute your fears of sharing.

When I dedicated time to think and write about it, my fear of sharing began to dwindle. What surfaced was that I feared being less creative and successful than I'd been in the past. I had finished college at the top of my class and won all kinds of awards while I was a student. I put massive pressure on myself to become *successful* after college using my creativity. I wanted to keep performing and winning and being the best. But the working world I entered wasn't like college. And so, I was scared to share my work, even my personal projects, because I feared exposing that I hadn't lived up to my potential. That I wasn't as creative as I used to be. That I wasn't successful.

This belief not only prevented me from sharing, but from creating much at all. The following arguments helped me begin sharing and creating again:

You are creative. And there will *always* be room for more creativity. Work on your creativity. But don't be defined by it.

You can't change the past. But you can choose what you do today. Choose to create, experiment, and play.

People's opinions of your creativity will not make a difference to how creative you actually are. Stop hiding. Be vulnerable. Be brave. And seek input.

No matter your level of creativity, sharing your work can still impact the world. *I SEE THIS SO OFTEN NOW*

That's a brief picture of what I went through in my mid-twenties. My first 100 Day Project, where I doodled random words, helped me break through my fear of sharing. Little by little. Day by day. By posting every day I became comfortable with exposing my creativity for the world to see. And it set me free to create more liberally. Without fearing what people would think about me and how creative I was.

Whatever your fears are, you can work through them. You can overcome them. It may take a while. It may take a lot of thinking. And reflecting. And writing. And talking.

Fear steals joy.

Fear hinders creativity.

Fear robs the world of what you have to offer.

It's worth fighting against your fear of sharing.

What if my project is hard to share?

You may think your project isn't shareable. If you're not drinking alcohol for 100 days, that's pretty personal. You may be thinking, "What *could* I possibly share anyway? My empty glass each day?" Hang on. That's pretty interesting.

Maybe your 100 Day Project is meditating. Or running. Contacting friends. Not watching porn. These are weird projects to share right!? Even writing each day is weird to share—especially if you're writing a book in a non-linear fashion. What do you share in these instances? Do you share? Should you share? Can you share?

Well, for starters, you don't have to share. And you don't have to share *every-thing* you do. But if you want to, you could turn sharing into a fun or interesting part of your 100 Day Project. There could be interesting ways of sharing something that's related to your project and what you're doing. If you're going sober for 100 days, you could share what you're doing instead of drinking, or an empty glass in some interesting or weird location. For meditating, it could be #100weirdThoughtsWhileMeditating. For writing, you could share a few of your favorite sentences you wrote each day. For running, it could be #100photosInMotion.

I KNOW YOU HAVE WEIRD THOUGHTS WHEN YOU MEDITATE

WE ALL DO!

There are ways to share your project. And there are people who care about your project, no matter what. There are people who will rave about you not drinking alcohol. There are people who will encourage you to not watch porn. There are clubs and centers and entire industries there to get you fit and healthy and eating right. People care—you may just need to find the right people and the right channels.

Even if your 100 Day Project is all about not being on social media, you can still text a friend, write yourself letters, journal, or plan an exhibit of your work for when you're done.

How can you make your project shareable? *OR PART OF IT SHAREABLE?*

How can you make *the act* of sharing part of your project?

How do I share my 100 Day Project?

Most people share their 100 Day Project every day on Instagram. They tag their post with #100DayProject or #The100DayProject if it's part of *The* 100 Day Project. They also add a unique hashtag to all their posts. Like #100DaysOfPuppets. Or #100CrazyDanceMoves. They do this so It's easy to see all the posts from *AND YOU* their project in one place. But anyone else can use that same hashtag. So it's *CAN'T DO* become common to create a separate account just for your 100 Day Project. *ANYTHING ABOUT IT*

But you can share wherever, with whoever, and however you like. As your project morphs and grows and progresses, you may even want to try different ways of sharing.

What if no one comments or likes what I'm doing?

If you're posting on social media, remember that this project is for you. Not anyone else. If you're enjoying it, if you're benefiting from it, if you're changing your life through it, then let that be enough. Don't let a lack of feedback hold you back from doing your project. And don't change what you do to get feedback—or else you'll continually be letting what you do be shaped by the changing opinions of the algorithm-led masses. You do you. And if you get some comments and feedback, and if you inspire others, then bonus.

If I was in your position, I'd try to get one piece of feedback from someone I trust and respect, rather than 50 likes and emoji comments on Instagram. Seek *that* someone out. Ask them personally. Email them. Think about why you're sharing and what you're hoping to get out of it.

How do I respond to good and bad feedback?

Feedback can be terrifying.

Like, what if a famous person says something nice to you? About *your* project? What do you say? And what do you say when someone gushes over your work? Like, compliments the fork out of it. Or wants to buy all your pieces. Or wants you to run a workshop. Or or or! Firstly, say "Thank you! That means a lot to me." Or something like that. You don't need to return the compliment—this is about you and what you've shared. Don't downplay yourself or what you've done. And if someone wants to pay you, don't settle for anything less than what you're worth.

When people have questions about what you're doing, answer them. Be nice. Be friendly. Be helpful. You don't have to write essays. A short but thoughtful and helpful response is perfect.

MAYBE NOT EVEN YOUR MOM ALL THE TIME

When people have critical things to say, remember that you cannot please everyone. Don't base how you feel about your project on what others say about it. But, how to respond to criticism? Base your response on what they said and who they are to you. I don't engage with outright nasty people or with people who have clearly not engaged with what I'm sharing. But I do engage with people who offer honest and helpful criticism—especially if they're someone I know and trust and respect. You don't *have to* agree with what they say, but it's always helpful to listen and consider what they have to say. And when people who don't understand what you're doing criticize your work I'd suggest thanking them for their feedback and leaving it at that.

"YOUR WORK SUCKS! STOP EVEN TRYING"
"Booooo!"

When people's comments strike a chord, whether it's a good or bad one, ask yourself, "Why did that strike a chord? Why did that get under my skin?" Get to the bottom of it. Take some time to understand the reason you felt like that. That's the best thing you can do. *Then* respond to them. It will be a better conversation this way.

DO IT SOONER RATHER THAN LATER

6

ADVICE →

A MUST READ

94
How can I get the most out of my 100 Day Project as possible?

97
How do I make it easy to start my project every day?

99
Can I stockpile?

99
Can I plan ahead?

100
Should I save my best creations for later?

101
Can I skip weekends?

103
Do I have to stick to 100 days?

103
Should I track my project?

104
Do I need to finish something every day?

104
Do I have to follow the rules?

105
What should I do if I compare what I'm doing to others?

106
What if I develop impostor syndrome?

107
When do I celebrate?

THERE'S A DOWNLOADABLE PDF LINK IN THIS CHAPTER

BEWARE: INCLUDES SARCASM

OH MY! SO MANY GOOD CHAPTERS

How can I get the most out of my 100 Day Project as possible?

BE A PIRATE

By doing something for 100 days, you're already going to get tons of good stuff. But there's always more metaphorical gold to plunder, jewels to pillage, and loot to pilfer. And it's all *your* treasure that you've worked for. Don't let it slip away. Don't let it sneak past you. So, how do you grab as much of it as you can?

Ask yourself questions. About everything in your project. About everything you do and don't do. And everything you feel. Especially after noticing something. Perhaps you noticed you're feeling confident one day. Maybe ask, "What's making me feel confident today?" Maybe you worked really fast on another day, so you could ask, "When do I create best?" Direct the questions at yourself. And try to answer them. If you don't have a question, start with a

RUDYARD's KIPLING'S 6 HONEST SERVING MEN.

question word and see what pops into your head. Examples of great question words are what, why, when, how, where, or who. *What* are my thought patterns when I'm feeling negative? *When* do I feel negative? *What* is my creation process? *Where* am I most productive? *Who* inspires me? *Who* am I jealous of? Your brain is pretty good at filling in the gaps after a question word. When you do this, you begin to surface what's going on deep down. You begin to bring the unconscious to the conscious, and it's often impressive. A simple question you could ask every day is, "What did I learn today?" or "What happened today, and why?" *THIS SIMPLE PRACTICE BRINGS SO MUCH CLARITY TO LIFE*

Experiment. Ask yourself, "What if I _____?" and come up with some options. And then select one to test out. What if I wake up at 5 a.m. and do my project? What if I do this while having coffee with a friend? What if I do this in a shorter time span? What if I focused on landscape photography? What if I focused on architecture photography? Once you've asked a question, see what feelings and thoughts come up. And then try something out. Doing this will force learnings on you. And it'll mean you have ammunition for future experiments and questions. *YOU CAN DO BOTH BIG AND TINY EXPERIMENTS*

Learn from the bad stuff. When something doesn't work, or if you discover you don't like something about your project, treat it as an experiment. No matter if it's a small part of your project or the entire thing. It's not a waste of time. It's a golden nugget. It's data you didn't have before. Now you have it and it reveals *something*. It helps you make better decisions in the future and eventually leads to a better way. Knowing that one way is wrong is far better than standing at a fork in the road and going nowhere, umming and ahhing. When you know that one option isn't right, you've got one less option to try—and therefore, more chances of success!

Answer questions from others. When you answer questions others ask you, and even when you answer questions you ask yourself, you take what you do intuitively and explain it and systemize it. You get what's going on in the background out into the foreground. And you begin to learn what you already know—which can give you a sudden swell of confidence and momentum.

Immerse yourself in your topic. If you're doodling for 100 days, learn all about doodling—the different ways to doodle, the benefits of doodling, who else doodles. If you're baking for 100 days, learn all about baking—different baking methods, what ingredients do what, how to bake different things. This could be watching YouTube videos on your commute, listening to podcasts while you exercise, choosing to watch documentaries about your topic instead of fictional movies and series. When you learn all you can, instead of just doing what *you* know, you learn what *you* don't know. You learn how things work. You begin to connect the dots. You learn the jargon and lingo and terminology. You learn who's who and why what they have to say is important. It informs what you do going forward—and why you do it.

Discuss your project with others. Whether they're on the same journey or not, and whether they have more or less experience than you, talking about your project will reveal how you think about it. It will allow them to ask questions. It will allow you to ask questions. Let them have input into what you're doing. Let them give you advice. Sometimes you'll have a blind spot they can see. Other times they'll have been through what you're going through and can help prevent all kinds of bad stuff.

NOT EVERY SINGLE ONE!
THE ONES THAT CATCH YOUR EYE.

Engage in other people's projects. This can be people doing similar projects to you, or completely different ones. Ask them questions. Tell them what you like. See how they're doing things. You may like someone's approach to planning and organization. You may like the way someone does their project without caring what anyone else thinks. You may learn about the different kinds of running shoes. Or what brand of paper is the best. Or why someone thinks Blender is better than Cinema 4D. Or what brush someone is painting with. When you take an interest in other projects, it sparks ideas, prompts you to question what you're doing, and gives you ideas on how to do your project better. Or in a different way.

Record things. Record how you feel. The ups. The downs. The decisions you make. The reasons. Your process. Record what you don't see at the end. What others say. What inspires you. What questions you have. Your answers. Record everything you could store in your brain. You could use a blog, a vlog, a journal, a voice recorder app, or a bunch of other ways. I record in my journal. When you record things you release your brain from storage management. You clarify what's swirling around in your mind. Release your brain to make sense of it—and create from it. You figure out what you know. You can see it all there in front of you. And you can look back at it, and relearn a bunch of stuff.

Keep going. Even when you think you've got everything you can from your project, sometimes showing up for a few more days leads to a giant breakthrough. Sometimes you figure out a better way of doing a small part in your project. Other times getting to day 100 is the cherry on top of everything— which is massive! You don't know what you don't know. And you don't know what will happen. Give 100 days a chance.

I recommend continually being on the lookout for treasure. Reflect on a daily basis—or as often as you can. Because learnings and wisdom and ideas and questions will pop up frequently. If you *only* do these reflections at the end it *will* help. But you'll probably have forgotten a ton—left-behind treasure! So, if you want to grab as much loot as possible, reflect consistently throughout your project.

REMEMBER, BE A PIRATE!

How do I make it easy to start my project every day?

Getting started each day is often the hardest part of any 100 Day Project. Sometimes even remembering that you're doing one can be difficult. So, here are some ideas.

AT A SPECIFIC TIME FOR A SPECIFIC DURATION

Put each day in your calendar. Don't only have your project on your to-do list. Because that thing is limitless. Add it to your calendar—it represents time much more accurately. Assign a piece of your life to it. And because most people live by their calendars, when you add it to your calendar, you're telling your brain that it's important and that you're serious about it. And no one, including you, can schedule something instead of it. Also, calendars send reminders. *IF THEY'RE DIGITAL*

Leave stuff out that reminds you to do your project. Leave your running shoes by the door. Leave your camera on the table. Leave your paint brushes and supplies on your kitchen table. Leave things out!

Practice Mise en Place. Say what now? It's a French cooking term for having everything in its place. Get your environment ready. Prepare your tools. Keep what you need out, and put everything else away. It makes it easier and more attractive to get started.

SMALL OR QUICK

Start tomorrow today. Do something today that helps you get going tomorrow. Create your file. Choose your subject matter. Pick your chords. Sketch your outlines. When you start working tomorrow, it'll be super easy to get into it.

Tell your significant other what you're doing. Wife. Husband. Girlfriend. Boyfriend. Someone who's going to back you up and support you. Someone who's going to switch off the TV after one episode. Someone who's going to do the dishes so you can learn a dance move. The same someone who could be a distraction or handbrake if you *don't* tell them.

Make it fun. When something is fun, you actually want to do it.

WHAT'S FUN FOR YOU?

Get into a routine. Humans like routine and ritual. If you can, do your project at the same time, at the same place, with the same parameters, with very little else changing, every single day.

Associate it with something that happens every day. Do it after a meal. We seldom forget about eating. If you can't live without coffee, do it before coffee, or while you drink your coffee. You also go to sleep and wake up every day. You brush your teeth every day. These kinds of things are useful to anchor your project onto. It makes it easier to turn your project into a habit when you attach it to your existing routine.

Plan what you're going to do and how you're going to do it. This may be more necessary for some projects than others. Know what app you're using. Know what topics you're writing about. Make time for planning if it's going to help you get started.

Do your project with someone else. This keeps you accountable. You can inspire each other, give each other feedback, and discuss your projects. You can also learn from them, and teach them—which cements what you've learned. You can also find or form a community to do your project.

Track your progress. Make a calendar. Or count the pieces/items you create. You can also create a tracker. There's a chapter about tracking on page 103.

You don't need to wait for someone else to create a community. You can do it.

Can I stockpile?

THIS IS A GOOD CONCEPT TO INTERNALIZE

As in create 4 days in one day and not create anything for the next 3 days? Technically, no. A 100 Day Project is where you work on something for 100 *days*. The point is not necessarily to create 100 items or do 100 things. It's not called a 100 *item* project. If you're stockpiling to maintain appearances, or to keep on sharing, I'd say you're missing the point. And if you see this as cheating you're the only one you're cheating.

If you do create more in one day, great! You can share what you created over the next few days. But then show up the next day and do the work. Whether it takes you seven days to create one item, or one day to create four items, keep showing up every day. *AS IS THIS ONE*

Can I plan ahead?

As in think about and plan what you're going to do on future days of your project? Of course! This is a great way to take the pressure off of each day—which can be a massive barrier to getting started.

You could plan ahead in set intervals, like a week at a time, and you could add ideas to a list when they come to you.

Should I save my best creations for later?

No.

Don't wait.

Don't wait to release the kraken. Don't wait to work on something epic. Don't *knowingly* work on something subpar when you know there's something better you could work on. Don't worry if you don't think you have the skills, or whatever else, to pull it off.

When you stretch for the best, and work on that epic creation today, you open up avenues and crossroads for creativity and imagination to pour through. When you work on that idea, more good ideas will follow. When you don't hold back, neither will your inspiration.

Conversely, if you practice not choosing your best work, you'll keep creating less-than-your-best work. Train your brain to seek adventure and curiosity and awesomeness. Not less-than-the-best or averageness.

Don't hold back.

Be generous. To yourself. And to the world.

Do the best with what you have. Go for the most exciting option each day.

Lean into the good stuff, not away from it.

PAGE 100

RELEASE THE KRAKEN!

Can I skip weekends?

Yup. You can. It's totally your call. You can also skip public holidays. And when you feel ill. And when the sun shines. And when it's raining. And any other time you feel like it. It's all *your* decision.

↗ I'LL STOP NOW

Okay, I'm being sarcastic. What I'm getting at is that there will be plenty of reasonable reasons to skip a day. If you're going to skip days, plan ahead which days you'll skip, rather than skipping when you feel like it. And, if possible, skip days in order to benefit you and your project.

Let's get back to weekends. Weekends seem normal to skip, because most of us skip working for 2 days on weekends. Because we need rest! We need a break. We need to do something different. I get that. Taking a break over weekends makes sense. But, you could alter your project over weekends to make use of the extra of time, or to include people you want to hang out with, or to rest better. You could create for longer. You could try something new. You could create a video about what you learned. You could do your project with your family. YOU CAN DO SOMETHING DIFFERENT INSTEAD OF SKIPPING

There are benefits to skipping weekends and to not skipping weekends. Do the one that's best for you and your project.

How will skipping weekends or creating on weekends benefit you and your project?

How could you alter what or how you do your project on weekends?

Are you going to skip weekends? Why?

Do I have to stick to 100 days?

Intend to stick to 100 days. That's what makes it a 100 Day Project. Adapt and change your project so that you *can* stick to 100 days.

If you decide to stop your project before 100 days are up, don't simply abandon your project. Read the Can I Quit My 100 Day Project? chapter on page 128 to quit like a pirate.

Conversely, if you want to continue working on your project past 100 days, that's awesome. Read the chapter about finishing your 100 Day Project on page 135.

Should I track my 100 Day Project?

Yes! Every time you mark another day as done, you get a hit of dopamine, the success hormone. And that feels good!

Sure, you can keep track of what day you're on when you share, or by numbering what you create, but physically marking days off is far more satisfying.

Track your progress however you like. The level of detail you track is up to you. And so is the decision whether you track completed days only, or completed and missed days. You can download and print this book's official Project Tracker at **www.ttkb.me/100dptracker** *IT EVEN INCLUDES QUESTIONS AND JOURNAL PROMPTS*

When I mark a day as done, I add the day out of 100, the date, and the day of week. I also enjoy writing down short journal-like entries.

LITTLE TIP:
IF YOU STICK YOUR TRACKING PAGE SOMEWHERE NOTICEABLE, IT DOUBLES AS A REMINDER TO DO YOUR PROJECT.

FOR EXAMPLE:

✓ D57 / 28.01. FR
FOUND IT EASY TODAY

✓ D58 / 29.01. SA
COMPARING MYSELF TO FAMOUS PEOPLE

✗ D59 / 30.01. SU
WAVES WERE GOOD!

Do I need to finish something every day?

This depends on how *you* design, or designed, *your* project.

If your aim is to complete a painting each day, well, that could take 5 minutes. Or 17 hours. What *finished* looks like is up to you. If you're a perfectionist or you have super high standards, this could translate into you spending far more time on your project per day than you planned. It could lead to overwhelm and project abandonment. Choosing to complete something each day, no matter what, is often more intense and challenging than the other option.

I CALL THIS THE WAY OF THE TORTOISE

The other option is to allot a certain amount of time to a creative action each day. Some people work on a book. Or a website. For a period of time each day that chips away at a big task. But you could also spend a predetermined amount of time each day on individual items. It's called a 100 *Day* Project. Not a 100 *item* project. You do what's possible within the time you have each day. Don't worry if you don't finish an item. You can pick up where you left off tomorrow. And if it takes you 3 days to create an item, that's cool. And if you create 5 items in one day, then that's cool too. Maybe you won't end up creating 100 items, but you will have showed up for 100 days.

Do I have to follow the rules?

WELL, IF THERE IS I'M NOT PART OF IT

Even if there were official rules, and you did follow them, there's no secret club or 100 Day Project completion ceremony. No one is checking up on you. The only rule you *need* to follow, in order for you to call your project a 100 Day Project, is doing (or attempting to do) something *creative* for 100 days. What that looks like is up to you. You design your own project. You make the rules. And it's your decision to keep or ditch them.

INTENTIONALLY PURSUING MORE OF WHAT YOU WANT IN YOUR LIFE, OR TRYING TO BECOME MORE OF THE PERSON YOU WANT TO BE

What should I do if I compare what I'm doing to others?

UNDERLINE, CIRCLE AND HIGHLIGHT WHAT YOU NEED TO. I WROTE THIS CHAPTER AS MUCH FOR ME AS I DID FOR YOU

Comparison is normal. Natural. Human. We like to see where we fit in. How we're doing. What we're missing.

But it can seriously affect our ability to do stuff. It can put us off. It can make us feel terrible. Not good enough. Unworthy. Lame. Useless.

So what can you do?

Know that you're the only person you can truly compare yourself to. Compare yourself and your work to past-tense you. Look back at how you've changed and grown and matured and developed. Focus on how different you are now compared to where you were a few days or weeks or months or years ago. Let that fuel you to become a better version of yourself.

Only you truly know how you're doing, where you are, what you're going through, and what you've been through. You may have just started creating 3D characters. You cannot compare it to someone who's been doing it for years. Someone who studied it at university for 5 years. Someone who's worked on feature-length films. Someone who can spend far more time on character design than you can. Someone who has tons more money and equipment than you do. Someone who may be spending 7 hours per day working on their 3D character. You may be learning *and* creating a character in only 1 hour each day. Without their experience. Without their context. Without a whole bunch of their stuff. But also with a whole bunch of *your* stuff—you bring a lot to the table. Your experiences. Your talents. Your gifts and strengths and humor.

Only compare yourself to yourself.

Get inspired by others, but don't let their success rob you of your own success. Just because someone else is successful doesn't mean you can't be too. And just because they're doing crazy-awesome things, doesn't mean you can't get there.

Do this project for you. Because you want to. Because you enjoy it. Because it makes your life better.

What if I develop impostor syndrome?

Take it as a good sign. Push through. No one, nowadays anyway, does anything worthwhile without feeling like an impostor. Pushing into the unknown will give you impostor syndrome. Knowing that you're not the best will give you impostor syndrome. Knowing that you don't know it all will give you impostor syndrome.

Of course you aren't *the* best.

Of course you don't know *everything*. *IF YOU THINK OTHERWISE, WATCH OUT!*

Of course there's more to learn.

Of course you don't know exactly what you're doing—that would be boring.

All the people doing awesome things don't know exactly what they're doing. They're all learning as they go. They're all making things up.

Feeling like an impostor is a sign that you *are* qualified to be doing what you're doing—exploring, experimenting, playing, learning.

If you're feeling like an impostor, you're in good company.

WELCOME TO THE CLUB.

When do I celebrate?

Whenever you like! And as big as you like! Each day is a tiny milestone that deserves a celebration. But there are a few specific moments that make a bit more sense than others:

At the start. You're about to embark on an epic life-changing project. So, at least do a celebratory dance! *YES! WHOOPO!*

After 1 week. You're gathering momentum, you're learning, your mind is ticking. You're doing this! Go you! Celebrate! *OH YEAH !!*

Halfway. This is a golden opportunity to mark having completed 50 days. To get a sense of how far you've come, look at what you've done. At what you've created. At how you've progressed. From tomorrow you'll have less days ahead than behind you. Celebrate! *BOOM!! YIPEEE!*

When you achieve. When you run your best, celebrate. When you make up a rad riff and you're amazed at how good it sounds, celebrate. When you receive a nice comment on Instagram, celebrate. *COME ON! YEEES!!*

At the end. Most definitely! Here's where you celebrate in a huuuuuge way!

When you celebrate, it could be something small like fist-pumping the air or wiggling your butt. It could also be bigger like going out for dinner or grabbing a beer from your favorite pub. Or my favorite, drinking chocolate milk. *CELEBRATE HOW YOU WANT*

If your butt wiggles become half-hearted, or if your woohoos become lame, then perhaps celebrate a little less frequently.

WHOOOOOOOOOOO

SIMPLY: CELEBRATE ANY TIME YOU WANT, AS LONG AS IT'S WHOLEHEARTED

THE JOURNEY

THERE ARE A
FEW INDICATORS

110
**How do I begin a
100 Day Project?**

112
**What if I'm spending
more time on my
project than I planned?**

114
**What happens if I
miss a day?** YOU DON'T
GO BACK TO
DAY 1

115
Can I skip a day?

116
**What if I get bored of
my project?**

118
**Can I change my project
during the 100 days?**

119
**When should I change
my project?**

122
What if I get stuck?

123
**What if I get famous
during my project?** IT MAY
HAPPEN

124
**What if I complete my
project before 100 days?**

* THIS WILL
MOST LIKELY HAPPEN

How do I begin a 100 Day Project?

Very simply, you choose something to do for 100 days and then you do it every day for 100 days. If you haven't chosen your project yet, read how to choose your project on page 32.

If you're sharing your project, tell people what you're doing and when you're starting. Tell them what to expect. Tell them why you're excited. And tell them how to follow your journey. If you're sharing on social media, share the hashtag for your project, or the account name of your project. You may want to include the following hashtags in this post too:

- #100DayProject
- #The100DayProject if you're participating in *The* 100 Day Project:
- Your hashtag. If you're baking all things Disney, maybe something like #100DaysOfDisneyBaking

And then...

- Gather your supplies and get ready for day one. Plan ahead if you need to.
- Celebrate. Dance. Do a jiggle. Whoop. Fist-pump the air. Smile to yourself.
- Begin when you said you would!
- Track your progress! Download a project tracker from **www.ttkb.me/100dptracker**

MORE THEORETICAL ANSWER HERE

If you were looking for a less practical answer, here's one. You won't know how your 100 Day Project is going to unfold. You'll likely have tons of doubts and questions. Some of them tangible, some of them hidden deep down. Will I have the stamina to create for 100 days? Will I get bored? Will I end up hating my project? Is this the best use of my time? Will it change my life in the way I hope? What if I get busy? Or stuck? Or sick? The answers to these questions shouldn't prevent you from starting. Let future-you deal with them. Let present-you focus on right now—on starting.

WHOOPO! GOOD LUCK! HAVE FUN!

THIS IS AS CLOSE AS I COULD GET TO A GIF OF ME DANCING IN CELEBRATION!

What if I'm spending more time on my project than I planned?

The answer to this question depends on the reason why you're spending more time on your project than you planned. Here are a few scenarios. You're taking longer than expected because…

You're learning a new skill *and* producing something each day. This is normal. You're still figuring things out. As you gain more experience, you should begin to get better and quicker at what you do. And you'll probably get better at estimating how long something will take you. So, give it time—you'll get quicker. Another solution is to set a timer for what you're doing every day. When time is up, stop what you're doing. Your brain will begin to realize it needs to work faster. Or you'll need to adjust your expectations of what's possible in that amount of time.

You're getting lost in what you're doing. This is an amazing feeling. But there are often other things you need to do and places you need to be. The first thing I suggest is tracking how much time you spend on your project each day. Once you know how much time you spend on average you have 2 options. Option one is to match the amount of time you *plan* on spending each day with the time you *actually* spend. You may need to reschedule appointments or do your project at another time in the day for this to work out. This option is a luxury, and you should only do this if you can and want to. Option two is to stop working after a predetermined amount of time—as you planned. Since you get lost in your work, setting a timer is a good idea no matter which option you choose.

You're trying to maintain or increase the quality of what you're doing each day. When this happens, it's common for you to take longer and longer—because you don't want to stop working until you reach a *certain* level. You stop taking breaks. You stress. You become overly critical of what you're doing. And you may even eventually abandon your project because it becomes too much. In this case, I'd suggest planning to spend far less time on your project each day and increasing the amount of parameters you use. So that it becomes *impossible* to create at a consistently high level. Take off the pressure. Make it fun. Make it play. Stop taking your project so seriously.

So, what's the reason you're taking longer than expected, and what are you going to do about it?

USING A TIMER
CAN OFTEN BE
A VERY GOOD IDEA

What happens if I miss a day?

Seriously, it's not a big deal. It happens to all of us. You can either double-up the next day, do one less day in your 100 Day Project, or extend your project by a day—100 Day Project participants do these things all the time. I don't recommend doubling-up because it's often overwhelming—especially if you've missed a couple of days and you're trying to catch up. *THEN YOU NEED TO SKIP A DAY TO TAKE A BREAK*

Now, it's good to know *why* you missed a day. Was there an emergency? Was it a sunny day for the first time in months and you decided to hit the beach? Were you working on an intense deadline? Did you forget about it? Did you start something else? Did you skip breakfast? Whatever the reason, make a note of it. If you're keeping a journal or using a project tracker, jot it down next to the day you missed. It will remind you why you missed a day, and provide insight if you miss any more days—you'll begin to see patterns.

** IMPORTANT STUFF HERE*
If you notice you're missing (or skipping) more and more days, especially lots of days in a row, it's normally not a good sign. The more days you miss the more you're communicating to yourself that it's okay to miss days. So when you notice yourself missing a lot of days, consider changing something about your project. You may need to make it more interesting, or reduce the time requirement. Or make it less intense. Because if you carry on without making a change, what often happens is that you stop physically working on your project, but you still have the mental tab for it open in your brain. Which uses up your brain's temporary hard drive space. Engage with your project. Make a change.

Can I skip a day?

Firstly, there's a difference between *missing* a day, and *skipping* a day. Missing is unintentional, or circumstantial. Maybe you forget, or maybe there was an emergency you had to take care of—you don't have time for creative projects while rushing someone to the hospital. Skipping a day is *intentional.* You're choosing to watch another episode over creating. You're choosing to sleep for another 30 minutes over creating. You're choosing to go to surfing instead. You're choosing not to show up.

So, yes. You can skip a day. If you allow yourself. It's your project. You're in control. But ask yourself why you want to skip a day, or why you *skipped* a day. What's the reason? Sometimes we need a rest day. Sometimes we need a break. Other times our project is starting to get boring. Or we needed to get some space from our project. Or to focus on a relationship. Write the reason down in your tracker or journal. *BE HONEST WITH YOURSELF*

If you begin skipping days all over the show, or skipping multiple days in a row, it's a sign that something most likely needs to change—what you're doing, how long you're doing it for, your parameters. Question why you're skipping so much.

Just like if you miss a day, when you skip a day, you can double-up the next day (not recommended), do one less day in your 100 Day Project, or extend your project by a day.

You 99% WILL GET BORED OF YOUR PROJECT

What if I get bored of my project?

You will most likely get bored of your project at *some* stage. Or with *some* part of it. And that's okay. Let that boredom inspire you to do something different or to do it differently.

Don't just accept your project as being boring. And don't believe that because you've already done 68 days of one thing, or 45 items that look so nice together, that you can't do something different.

Change something. ➔ *SCENARIO ONE*

You don't have to wait for things to get better. Make them better *now*. Perhaps you need a reminder of that. Acknowledging this often breathes new life into your project.

You can make it what you want it. Even if you need to change it completely.

At times, though, boring is good. Like, very good. ➔ *SCENARIO TWO*

Some boring stuff produces magic—discipline, consistency, that kind of stuff. Sometimes doing the boring stuff well is *the key* to success. But sometimes that success only appears on day 89. Sometimes the process needs to be boring in order for the outcome to be magical. You may need to look at the bigger picture of what you're doing—which is often awesome and exciting and epic—and suck up the immediate boredom in exchange for what it enables.

ONLY YOU WILL KNOW WHICH SCENARIO YOU'RE IN

What's boring you? And what can you change to make it more exciting?

Can I change my project during the 100 days?

DON'T WORRY, YOU DON'T GO BACK TO DAY ONE

Yes. Of course you can pivot and adapt it. Or change it completely. It's allowed! It's even encouraged! It's often necessary and healthy to change your project. As you progress through your project *you* change. You grow and learn and succeed and fail and make decisions and do hard stuff. You discover what you do and don't like. What you do and don't want. What's difficult and easy for you. What you're capable of. You get better. You become more capable. More confident. Faster. More focused. Some things will get easier. Some things will get accumulatively more difficult. Some things will get boring.

So, as you evolve, evolve your project. Sometimes it needs minor adaptions. Perhaps more challenging parameters. Or different subject matter. Or a different time of day. Other times it needs drastic changes. Your project is boring you. You're not sleeping due to the stress your project is causing you. You've finished writing your screenplay in 30 days.

Change your project 7 times in 100 days, and learn a ton, rather than doing the same thing without changing, and without learning anything. The important thing about change is knowing why you're changing, and learning as much as you can during the process—especially about yourself.

This is your 100 Day Project where you're bringing in the change you want to see in your life. Change your project to make it what *you* want and need.

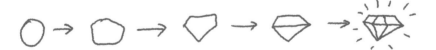

When should I change my project?

When you *should* change your project isn't formulaic—I don't want to say that *when* something happens you *should* change your project. But there are recognizable signs that suggest change may be a good idea. When you see these signs, it may be worth inspecting your project and making a change before it's too late—before you wake up one day and realize you let your project crash and burn. So, what are the signs?

When you *feel* like changing your project. Feelings are here for reason. Don't ignore them. Listen to them. Get to the bottom of them.

When you're bored of your project. If you're bored, you're less likely to care about your project, less likely to learn, less likely to show up.

When things get easy. If something gets too easy, we often get bored, comfortable, or complacent. Maybe you can play *Chopsticks* on your piano after 42 days. But have you tried making your own music yet? Set yourself a more challenging task.

WELL
DONE !

When it's just too hard. One or two days of difficulty can be tolerated and pushed through. But when it's constant, it can become tough to keep on showing up.

When it causes stress. A little stress is good, but large amounts of stress over 100 days isn't good.

When it frustrates you. Some frustration can help you learn and innovate. But other times frustration leads to project abandonment—you don't want this.

When life changes. Your relationship with your family may need the lion's share of your attention right now, after 28 days of your project. You may be burning out professionally and need to switch to focusing on relaxation. Or you may have landed a new job that requires you to learn a new skill. Sometimes quitting *is* the best option, but there are other ways to keep doing your 100 Day Project—even if it becomes very stripped back and simple.

When you get to the end. If you're done, well, you're done. There's no mountain left to climb. If you're writing a book for 100 days and it only took you 62 days, change the remainder of your project into something else—promoting the book, writing a second book, writing daily, or chilling hard.

When you're skipping or missing many days. Missing or skipping one or two days here and there is fairly normal. But if you're missing weeks at a time, think about making some changes. *UNLESS THIS IS THE CADENCE YOU WANT*

When you're spending far more time on it than you planned. You may be *loving* your project and spending as much time as possible on it every day. That's awesome but this could lead to you dropping balls elsewhere. Or you're spending so much time because you're comparing yourself to others, or because you're giving into perfectionism.

Ultimately, if anything is preventing you from doing your project as you want, or if there's anything in your power that could make it more of what you want it to be, change it. Keep on asking what you need. Keep on adapting. Even in tiny ways. And if you're keeping a journal, make note of what you're changing and why. Or what you're keeping the same. Because sometimes keeping something the same is exactly what you *actually* need.

THAT'S A GOOD CONCLUSION

What signs are pointing toward a project change? What are you going to change? And what are you hoping will change?

What if I get stuck?

This is sometimes called creative block. You're not inspired. You're blanking. The blank page is scaring you. You're scared to start. You're afraid of messing up. You can't think of *anything*. What to do?

Don't beat yourself up. This happens to everyone. There are four things I'd suggest doing if you get stuck:

Start small. Give yourself five minutes to do *something*. Or even one minute. Just commit to that. If running every day is your 100 Day Project, commit to putting your running clothes on—that's all. You can call that a day in your 100 Day Project. If you're writing, commit to sitting down and writing for five minutes— that's all. Lower your expectations.

Do something different. Something outside the realm of your project. Just for 5 minutes. It can be anything. It doesn't have to be related to your project. Doodle a random word. Draw something based off of what you read on Wikipedia's featured article page. Make up a rap using a headline from a newspaper article. Write a haiku. Create *something*.

Get away from your desk. Get your mind off your project. Get outside. Go to a museum. Sit down at a café. Go for a walk. Watch a movie. Read a book outside. Play ping-pong. Sing karaoke. Hang out with friends. These kind of things unconsciously influence our creative minds, and relax our brains.

Change your project. This isn't option 1. But is an option—especially if the stuckness persists. Do something that's easier. Lower the barrier. Make it easier. Make it different.

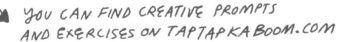

YOU CAN FIND CREATIVE PROMPTS AND EXERCISES ON TAPTAPKABOOM.COM

What if I get famous during my project? *CONGRATS ?*

Enjoy it. Be generous. Be kind. Be wise.

Everyone will want a piece of you and many people will want to exploit your momentum and fame. Also, it may not last forever. And it will most likely feel normal after a few weeks. There's always more fame, more attention, more money, more more more to be had.

What does being famous look like to you?

Keep on doing your project for you, and not for more fame and popularity. Don't get stuck pandering to what people want from you—to their expectations and what's working on social media. Don't worry about your popularity or engagement. Concern yourself with doing stuff that you'd do even if no one was watching, looking, or commenting.

DON'T AIM FOR FAME OR COUNT ON IT.

What if I complete my project before 100 days?

Sometimes this happens. You publish your app on day 72. You submit your manuscript on day 49. You launch your business on day 33. Firstly, well done! It's a big deal. Secondly, you should celebrate! What you do next depends on what your project is, and how many days you have left. Here are some options:

Adapt your project. Instead of writing the book, market it for the remainder of your project—blog about it, make videos, organize interviews, that kind of thing. Instead of developing the app, get it into users' hands. Interview them. See what needs improving. With this approach, your project is still about the same thing, just a different expression of it.

Keep on going. Begin writing a sequel. Work on version 2. Take your project to the next level—it's all a bonus!

Do something different for the remainder of your project. Spend the next 34 days relaxing every day. Or learn to bake sourdough bread. Or read fiction every day. Treat it as a mini 100 Day Project. Read the How Do I Choose My 100 Day Project? chapter on page 32 to help you find a new project.

Stop your project and get onto something else. You don't have to keep on doing your 100 Day Project when you're done. If you feel like it truly is the end, cross it off your to-do list and start working on something else, or go back to "normal" life. Read the What Do I Do When I Finish My 100 Day Project? chapter on page 135.

This chapter is only relevant if your 100 Day Project was a linear project—one with an end. If you're doing something every day for your project and you feel like it's come to an end, read the Can I Quit My 100 Day Project? chapter on page 128.

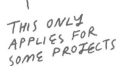

THIS ONLY APPLIES FOR SOME PROJECTS

What are some options to consider doing for the rest of your 100 Day Project?

ENDING
YOUR
PROJ

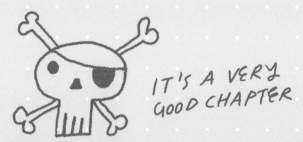

IT'S A VERY GOOD CHAPTER

THIS IS **THE** PIRATE CHAPTER

YOU GOTTA READ THIS ONE

128

Can I quit my 100 Day Project?

134

Can I call my project a 100 Day Project if it's not 100 days long?

135

What do I do when I finish my 100 Day Project?

141

How many 100 Day Projects should I do in a year?

Can I quit my 100 Day Project?

Yes. You most certainly can quit. You didn't sign a contract. You're not getting paid to do it. And I'm not giving you a medal or admitting you to a secret club when you finish. There's also no kind of punishment or repercussion if you quit. Not from me. This is your 100 Day Project. And the decision to quit is yours to make. So yes, you can quit.

THAT WOULD BE PRETTY COOL

But.

You knew there was a "But" right?

But...if you're going to quit, quit like a pirate.

In other words, don't leave empty-handed. Don't nonchalantly stop showing up. Don't abandon your project. Don't let it fizzle out. Don't turn your project into one you're working on but never doing any work on.

Because if you do, your confidence will likely get bruised and battered. You may feel like a failure. You may swear never to do a 100 Day Project again. Or any kind of project. You may never figure out what went wrong—doomed to repeat your mistakes again and again.

Don't rob yourself of the loot and plunder you can take with you when you quit.

Take as much gold and jewels with you as you can. Get as much of the benefits of doing, but not completing, a 100 Day Project as you can.

Of course I'm not talking about real gold and jewels here. Duh.

The loot I'm talking about is learning and understanding and insight and wisdom—modern-day creative gold. And there's a ton of this metaphorical treasure to be pillaged from your 100 Day Project—especially on your way out. Whether you leave midway through your 100 Day Project, or when the 100 days are up, you're still leaving. So grab as much as you can before abandoning ship.

Hang on.

AWKWARD...

Before we start talking about quitting, what if you're reading this and you haven't even started your 100 Day Project? That's like discussing divorce on your wedding day. It doesn't sound like a great start. Don't worry. Asking questions now is a good thing. And it allows me to give you a pep talk (coming up).

If you're already part-way through your project and ready to loot and plunder it, skip to the *For the Part-Way-Through-Your-Project You* section.

FOR THE PRE-PROJECT YOU

Sometimes quitting makes sense. Sometimes it *is* the best decision. Sometimes you've run up a mountain, only to realize it isn't *your* mountain. So why spend another 61 days up there when you could be climbing another? You may have found the crown jewel you were after or finished your 100 Day Project before 100 days. No point walking around pretending to look for the thing already in your hand. Other times you have to quit. And there's nothing you can do about it. You've got a ton of amazing high-paying work coming in. Your toddler needs ALL your attention. Sometimes your project is taking too much of a toll. You're stressed. The rest of your life is a mess because of how much time you're pouring into your 100 Day Project. Other times your project isn't adding any value to your life. Or it's bumming you out. What you thought would be an awesome 100 Day Project just isn't. There are good reasons to quit a 100 Day Project.

But pirates don't care about quitting or not quitting. They're after treasure. As much as possible. And your project will have tons of it. There'll be a mixture of easy-to-reach jewels and buried treasure chests that require digging.

If you haven't started your 100 Day Project yet, be a pirate. *I EVEN HUNG A PIRATE FLAG IN MY STUDIO*

Pirates take risks. They experiment. They try crazy things. They explore the unknown. They take on challenging projects. But they're not stupid—when things get boring or hard, or if something's not working, they learn from it. They gain wisdom, understanding, and knowledge of their craft—all of this sought-after treasure. Then they adapt. They change course. They learn from their mistakes. Because they want more loot. They keep going—in a new direction, with a new plan, with new knowledge and insight.

Your intention *should be* to show up for 100 days—and to make adjustments so that you *can* keep on showing up. This pirate attitude will transform your project from just another project into a 100 Day Project. It will turn difficult moments, even moments when you do quit, into significant learning moments where you absorb as much as you can.

Sometimes quitting makes sense. When necessary, pirates abandon ship. But they go down looting and plundering. If this happens, return to this page for help on how to plunder your project before you send it down to Davy Jones' Locker.

Now, back to your project!

→ MAYBE TEAR THE CORNER OF THIS PAGE ...

DO IT!

FOR THE PART-WAY-THROUGH-YOUR-PROJECT YOU

First of all, give yourself a high five. By quitting like a pirate, you're doing the opposite of failing. And *you* are certainly not a failure. You're certainly succeeding *more* than if you completed 100 days without learning anything. Because failing to learn—especially when quitting—is true failure. The 100 days is not the most important part—what you gain during the experience is.

I ADAPTED THIS FROM STEVE JOBS →

I would rather you quit like a pirate than do a 100 days in the navy.

Choosing to quit like a pirate takes guts. Because you're quitting a project you designed for you. A project you hoped would usher in what you needed and wanted.

Give yourself another high five. *→ SERIOUSLY. WHO CARES ABOUT THE WEIRD LOOKS YOU'LL GET. YOU'RE A PIRATE.*

Because it's far easier to leave in a myriad of unprofitable, unlucrative, unhelpful, unbeneficial, unfruitful, unproductive, unvaluable, unrewarding, unadvantageous, destructive, stupid, lazy, and idiotic ways.

You're quitting the right way. The pirate way. You're going down and taking as much with you as you can.

Now, let's pillage your project for wisdom, insight, learnings, and knowledge. So that it sets you up for future successes. So you're not doomed to repeat your mistakes over and over again. Take some time to answer these questions— some or all of them. Take the time to search for jewels and gold. *OVER THE NEXT FEW PAGES*

Why do you want to quit? What are your reasons?

The reasons you wrote down may be big reasons. And they may be small and seem silly and stupid and insignificant—but they're still the ones sinking the ship. By acknowledging them and writing them down you may see your project with new eyes. You may take renewed ownership. You may see your reasons as excuses. Or it may simply aid the looting and pillaging.

What happened during your 100 Day Project? Here are some questions to get you looting and pillaging:

- What have you learned? And can you apply that to other situations and projects?
- What have you enjoyed and hated about your project?
- Did you get what you wanted from your project?
- What would you do differently if you had to start again?
- What worked well and not-so-well in your project? And why?
- Was there a particular moment when things shifted or changed? What happened?
- What's different between now and when you started?
- What are you excited for next?

CARRY ON WRITING ON THE NEXT PAGE IF YOU NEED TO

Now, if going through these questions has given you a taste for treasure, and you've got some wind back in your pirate sails, and you're ready to *unquit* and get back on the high seas—perhaps in a new direction, or with renewed passion—then get back to your project! Give it no quarter. *ARRRG !*

If you are indeed quitting, and you feel like there's nothing more to pillage, I want you to strike this project off of your to-do list. And celebrate! Then spend your time intentionally and purposefully doing something else. Free up your mind. Free up your time. Go be a pirate somewhere else. *AAARRGG!*

Can I call my project a 100 Day Project if it's not 100 days long?

If you quit your project midway through but you started with the intention of completing all 100 days, then yes! Call your project a 100 Day Project. If you learned a bunch of stuff and if the process changed you, then your 100 Day Project did what it was supposed to do.

HOPEFULLY LIKE A PIRATE

↓

PAGE 128

If you feel like carrying on past day 100, then you could turn it into a 365 day project, or maybe even a daily practice. Read the What Do I Do When I Finish My 100 Day Project? chapter on page 135 for more information.

In both scenarios above, the intention was to complete 100 days when you began.

TUESDAYS + THURSDAYS FYI

Maybe your 100 Day Project is an irregular one: doing 1 day a week for 100 weeks. Or 100 days of weekdays. Or 100 days beginning with the letter T. Maybe even 100 weekend days. But 100 days! Make it revolve around that. If it doesn't revolve around 100 days, then it's not really a 100 Day Project is it? You don't *have* to do it in consecutive days. You *can* take as long as you like. It's still a 100 Day Project if you take 400 days from start to finish—as long as you work on it for 100 days.

#100DAYSOFCHILL OR #100WEEKENDDAYS

What's your definition of a 100 Day Project?

What do I do when I finish my 100 Day Project? *NOW WHAT??*

I've always wondered how Frodo Baggins, from *The Lord of the Rings*, felt after he destroyed the ring of power. Or how Sam Witwicky, in the first *Transformers* movie, felt after he helped save the world. Can you go back to "normal" life after this? You've just saved the world. Now what?

Maybe you feel like this. Like a hero. Finishing a 100 Day Project is a big thing. Especially if it's your first time. You may also feel relieved—thank goodness this thing is over. And excited to get onto something else! And emotional—you forking did it! But what comes next?

CELEBRATION!

Celebrate however you want.

TRY ALL OF THEM

Dancing. Jiggling. Confetti. Screaming and shouting. A quiet fist bump. A vacation. A fancy dinner. Champagne. A new iPad. I like celebrating with chocolate milk. And weird dancing.

Take this celebration part seriously.

You've just done something for 100 days. It's epic. It's brave. It's courageous.

Congratu-forking-lations.

When you've calmed down—after you've danced and drunk a few liters of chocolate milk, or when you come back from your Parisian vacation—you can begin to process what's next.

THESE WEIRD DANCE MOVES ARE FOR YOU!

REFLECT

The first thing I suggest doing post-celebration is some reflecting. And I recommend doing this as soon after you complete your project as possible—so things are still fresh. Reflecting on your project will help you leave with tons of treasure. And there are all kinds of shiny things waiting for you to find.

What happened during your 100 Day Project?

Here are some questions to get you thinking, reflecting, and processing:

- What have you learned?
- What's different between now and when you started?
- Did you get what you wanted from this project?
- What was difficult?
- What did you enjoy?
- What did you change in your project? When? And why?
- How does all this make you feel?

ANSWER SOME OR ALL OF THEM.

THERE'S MORE SPACE AT THE END OF THE BOOK

If you've been keeping a journal during the project, or if you used the online project tracker, take a look at some of the things you wrote.

THINK ABOUT NEXT TIME

SCANDAL! IS THE TITLE OF THIS BOOK A LIE?

No project is *actually* perfect. We're humans—perfect is not in our nature. So, maybe your project was perfectly imperfect. But that doesn't mean you wouldn't change anything right!? You most likely won't do the exact same project again. You couldn't even if you tried—because you'd feel different and be in a different emotional and mental space. But it's good to make note of things you *would* change. For future 100 Day Projects and other kinds of projects.

So, what would you change about your 100 Day Project?

I have some questions to prompt some thinking:

- **What would've been nice to know before you began?**
- **What advice would you give to pre-100 Day Project you?**
- **What would you do differently next time?**
- **What worked and what didn't work?**

KEEP IT GOING

When you began your project you wanted to change your life in some way. Add something. Remove something. Try something. Whatever it was, you've done it for 100 days. Maybe it wasn't all you hoped it would be—that happens. But maybe you feel the change. Maybe you want to make the effects of your project stick around. You don't want to go back to how things were. You want to keep up the momentum. Maybe you want to take it further. Maybe you want to maintain it—but not at such an intense level. Maybe you *do* want to keep doing it daily and turn it into a 365 day project or a daily practice or habit. You can take what you learned here and implement it into how you do life—in whatever way you please.

OR A
CHANGE

Is what you've done every day for the past 100 days worth keeping in some form or version? What could that look like?

WHAT'S NEXT

Now that you've completed this 100 Day Project, whether it's your first or seventh, and you have an idea of how to make change happen in your life, you'll likely have *a ton* of things you want to do. As you neared the end of your 100 Day Project, you most likely had things calling for your attention. The pull to get on to other projects is real! This is what often gets me through the last few days—the prospect of working on something new. What I suggest is writing down all the things you want to do next. Ask why you want to do them and what excites you about them.

So, what's next for you?

Here are some helper questions:

- **What have you been wanting to do, and waiting patiently to do while you finished your 100 Day Project?**
- **What new curiosities have you developed?**
- **What could your next 100 Day Project look like?**
- **What do you need and want now?**

I recommend doing the things on your list one at a time. Take it slow. Focus on what you want more of in your life. You can even revisit some of the questions and exercises in this book.

BE A TORTOISE! TAKE IT SLOW.

SHARE WHAT YOU MADE ——⟶ *I WANT TO SEE!*
AND MOST PROBABLY TONS OF OTHER PEOPLE.

If you made stuff during your project, think about sharing it all—as a whole. Some people may not have seen what you shared every day (thanks algorithm). And some people aren't on the places where you share.

What could sharing your project as a collated whole look like?

And once again, congratulations.

You rock.

Big time.

You are a champion.

Keep on asking what you need and want, and keep on taking action.

WHOOPO!

SHARE WHAT YOU LEARNED ——⟶ *I WANT TO HEAR!*

You'll most likely have learned a lot. Why not share it? You could write a blog post, record a video, or email a few people. When you share and help others you cement what you learned, and often uncover a bunch of stuff you didn't know you knew.

How many 100 Day Projects should I do in a year?

Unless you overlap projects (which I advise against), you can do a maximum of three per year.

If the structure of a 100 Day Project helps you make your life into more of what you want it to be, keep using it. By doing three 100 Day Projects a year, you're saying that you're going to create at least three changes in your life each year. That's pretty big. And it can be pretty intense.

But you don't have to follow the structure of a 100 Day Project every time you want to make a change or do a project. Some things don't fit into the 100 Day Project structure. Some things you want to do may be small. You could do them in a weekend. You could do a 10 or 30 day project. You could even smash it in one day. What you learned doing a single 100 Day Project may be all you need to keep on taking action and implementing change in your life.

GOOD TO KEEP IN MIND

Before starting a new 100 Day Project, go through the Choosing Your Project steps on page 32.

THE LAST FEW QUEST

DON'T BE SAD.
THIS IS THE END
OF THE BOOK, BUT
NOT THE END OF
YOUR CREATIVE
JOURNEY.

I'M SURE
YOU HAVE AT
LEAST A FEW

GOOD THINGS
TO KNOW

AS THEY SURELY WILL

144

**What are the links for all
things 100 Day Project?**

145

**What if I have questions you
didn't answer in this book?**

145

What if things change?

146

Are there any thank yous?

OF COURSE!

IONS

What are the links for all things 100 Day Project?

IN MY OPINION While this book is awesome, it doesn't give you the ability to connect, ask questions, join the community, or get involved. But this page will point you in the right direction.

FOR ALL AND ANY 100 DAY PROJECTS

- My 100 Day Project online course: **www.ttkb.me/100dp**
- My 100 Day Project website: **www.ttkb.me/my100dp**

FOR *THE* 100 DAY PROJECT

- *The* 100 Day Project website: **www.the100dayproject.org**
- #The100DayProject on Instagram: **www.instagram.com/explore/tags/the100dayproject**
- *The* 100 Day Project Facebook Group: **www.facebook.com/groups/the100dayprojectgroup**

What if I have questions you didn't answer in this book?

I would love to hear them.

Seriously. Send them my way.

Also, if you have comments, suggestions, stories, or answers to questions I didn't cover, send them too!

And if you find typos, spelling, and grammar errors!

My email address is **rich@taptapkaboom.com**

← *YES TO ALL OF THIS!*

What if things change?

Things will most certainly change. New topics. New people. New information. Maybe even new chapters! For all book updates and extra chapters and interviews and more stuff, visit **www.ttkb.me/100dpbookupdates**

Are there any thank yous?

Of course.

Thank you. For reading this book. For showing up. For taking action. For inviting change into your life. For opening a door to learning. For being a pirate. Imagine the entire world taking this step.

Chantelle, my wife and business partner. You encourage me. You do the boring things that drain the life from me. You take action whilst I dream. You read the drafts. You read my rambles. You tell me when things I write are stupid—and when they're good! You're honest. You listen. You make sense of me. You rock my world. You enabled me to write this book. Thank you.

Zoë, my daughter, thank you for keeping me company while I wrote this book. You're adventurous and curious. You take risks. You get up when you fall. You try everything. You inspire me and bring me joy every day.

Maggie at Rocky Nook, thank you for your prompts and reminders and questions and editing and patience and confidence in me and everything else you did that I didn't see.

Frances, thank you for making the inside of the book epic. It was a pleasure working with you.

BLANK PAGES

Write and draw and doodle and paint and paste whatever you want from here on out. Notes. Stories. Photos. Lyrics. Heartfelt letters. Your own chapters. Whatever. These pages are just for *you*.

THE PERFECT 100 DAY PROJECT

INDEX SO MANY QUESTIONS!

How does this book work? **vi**

Who wrote this book? **viii**

Why did you write this book? **ix**

1. The What and the Why

What is a 100 Day Project? **2**

Why are 100 Day Projects so popular? **4**

Is a 100 Day Project difficult to do? **5**

Why should I do a 100 Day Project? **7**

Why shouldn't I do a 100 Day Project? **13**

2. Common Objections

What if I'm not creative? **16**

What if I don't have enough _____? **18**

What if I'm a perfectionist? **19**

What if I'm a procrastinator? **19**

What if I'm horrible at sticking with anything? **20**

What if I'm stuck? **21**

3. *The* 100 Day Project

What's the difference between a 100 Day Project and *The* 100 Day Project? **24**

What's the history of *The* 100 Day Project? **27**

What are the dates of *The* 100 Day Project? **29**

Do I have to start and end *The* 100 Day Project with everyone else? **29**

4. Designing Your Project

How do I choose my 100 Day Project? **32**

Do I need to do a "creative" project? **60**

Can I merge what I'm currently working on into a 100 Day Project? **60**

What types of projects are there? **61**

What makes a good project? **62**

What if I'm struggling to choose my project? **63**

What if my last project was a huge success? **65**

How do I choose my subject matter each day? **67**

Can I pick an outcome-based goal to achieve for my 100 Day Project? **68**

What if someone has already done my project? **70**

How much time should I spend on my project? **72**

What if I'm traveling during my 100 Day Project? **73**

Can I do more than one project at a time? **73**

5. Sharing

Who should I tell about my 100 Day Project? **76**

Should I share my 100 Day Project? **78**

What are the benefits of sharing my project? **81**

What are the benefits of not sharing my project? **83**

How do I overcome the fear of sharing my work? **84**

What if my project is hard to share? **88**

How do I share my 100 Day Project? **90**

What if no one comments or likes what I'm doing? **90**

How do I respond to good and bad feedback? **91**

6. Advice

How can I get the most out of my 100 Day Project as possible? **94**

How do I make it easy to start my project every day? **97**

Can I stockpile? **99**

Can I plan ahead? **99**

Should I save my best creations for later? **100**

Can I skip weekends? **101**

Do I have to stick to 100 days? **103**

Should I track my 100 Day project? **103**

Do I need to finish something every day? **104**

Do I have to follow the rules? **104**

What should I do if I compare what I'm doing to others? **105**

What if I develop impostor syndrome? **106**

When do I celebrate? **107**

7. The Journey

How do I begin a 100 Day Project? **110**

What if I'm spending more time on my project than I planned? **112**

What happens if I miss a day? **114**

Can I skip a day? **115**

What if I get bored of my project? **116**

Can I change my project during the 100 days? **118**

When should I change my project? **119**

What if I get stuck? **122**

What if I get famous during my project? **123**

What if I complete my project before 100 days? **124**

8. Ending Your Project

Can I quit my 100 Day Project? **128**

Can I call my project a 100 Day Project if it's not 100 days long? **134**

What do I do when I finish my 100 Day Project? **135**

How many 100 Day Projects should I do in a year? **141**

9. The Last Few Questions

What are the links for all things 100 Day Project? **144**

What if I have questions you didn't answer in this book? **145**

What if things change? **145**

Are there any thank yous? **146**

Blank Pages **147**